THE ~~GOLDEN~~ ~~AGE~~ OF COUTURE

Paris and London 1947–57

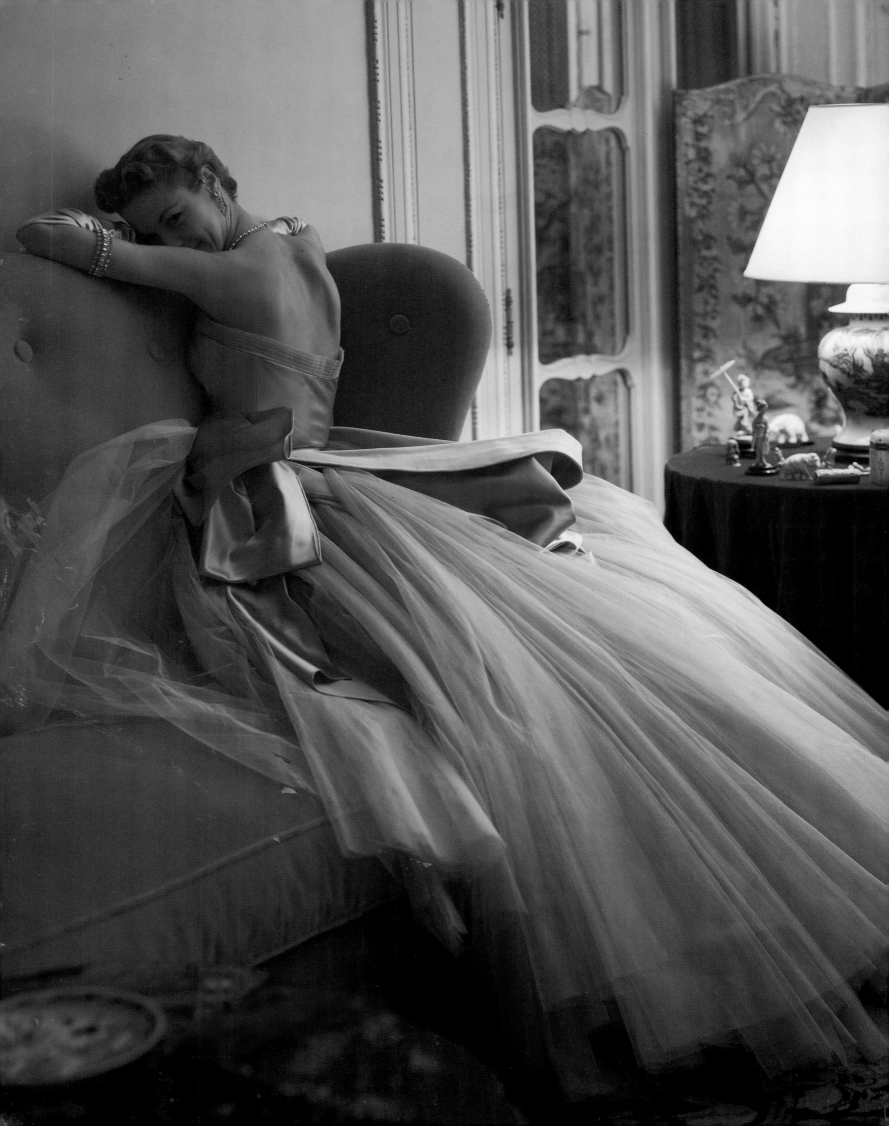

THE GOLDEN AGE OF COUTURE

Paris and London 1947–57

EDITED BY CLAIRE WILCOX

V&A PUBLISHING

First published by V&A Publications, 2007
This edition published 2008
V&A Publishing
Victoria and Albert Museum
South Kensington
London SW7 2RL

Distributed in North America by Harry N. Abrams, Inc., New York

Paperback edition
ISBN 978 1 85177 521 7

10 9 8 7 6 5 4 3
2011 2010 2009 2008

Designer: Nigel Soper
Copy-editor: Catherine Blake
Indexer: Vicki Robinson
New V&A photography by Richard Davis, V&A Photographic Studio

Printed in Singapore by C.S. Graphics

V&A Publishing
Victoria and Albert Museum
South Kensington
London SW7 2RL
www.vam.ac.uk

Front cover illustration:
Evening dress by Pierre Balmain.
Printed silk, 1957.
L'Officiel, March 1957.
See V&A: T.50–1974

Spine illustration:
Cocktail dress by Christian Dior
(London). Organza, 1957.
Illustration created for the
V&A by David Downton
© David Downton

Back cover illustration:
'Bar', later modelled by Renée.
Photograph by Willy Maywald,
1955

Inside cover illustration:
'Ruins rise, and beauty has
its second spring' *Vogue*,
(British edition), June 1947.
Photographs by Clifford Coffin

Frontispiece:
Evening dress by Jean Dessès,
modelled by Jeannie Patchett.
1950. Photograph by Norman
Parkinson

Page 8
Christian Dior house models
wearing the Spring/Summer
1957 collection. Photograph
by Cecil Beaton

CONTENTS

List of Contributors

Christopher Breward is Acting Head of Research at the V&A and a Professorial Fellow at London College of Fashion, University of the Arts, London. He was co-director, with David Gilbert, of the ESRC/AHRC 'Cultures of Consumption' Research Project: 'Shopping Routes: Networks of Fashion Consumption in London's West End 1945–1979' and co-edited the accompanying books, *Swinging Sixties* (2006) and *Fashion's World Cities* (2006). Other recent publications include *Fashion* (2003) and *Fashioning London* (2004). He was also co-curator of the Museum of London exhibition *The London Look* (2004–5).

Amy de la Haye is Reader in Material Culture and Fashion Curation at London College of Fashion, University of the Arts, London. Much of her curatorial and published works have focused on London fashion. Formerly Curator of Twentieth-Century Dress at the V&A, she curated the exhibition *The Cutting Edge: 50 Years of British Fashion* (V&A, 1997). She is currently co-authoring a V&A book about London couturier Lucile, curating an exhibition about the Women's Land Army and co-authoring a book on fashion curation.

A graduate of the Institut d'Etudes Politiques de Paris, with a doctorate in history of art, **Catherine Join-Diéterle** has been Curator-in-Chief of the Musée de la Mode et du Costume de la Ville de Paris since 1989.

Eleri Lynn is Assistant Curator of the V&A's exhibition, *The Golden Age of Couture: Paris and London 1947–1957* (2007). Previously she assisted with the exhibition *International Arts and Crafts* (V&A, 2005) and the V&A's Medieval and Renaissance Galleries project. She also coordinated the V&A's *Fashion in Motion* series in 2005.

Lesley Ellis Miller is Senior Curator of Textiles at the V&A. She has published extensively on eighteenth-century French luxury textiles, and is co-editor of the academic journal *Textile History*. A much-revised second edition of her 1993 monograph on the Spanish fashion designer Cristóbal Balenciaga will be published to coincide with the V&A exhibition, *The Golden Age of Couture: Paris and London 1947–1957* (2007).

Alexandra Palmer is Senior Curator, Textiles & Costume, at the Royal Ontario Museum where she has curated numerous exhibitions including *Elite Elegance: Couture Fashion in the 1950s* (2003). Her book *Couture and Commerce: the transatlantic fashion trade in the 1950s* (2001) won a Clio award for Ontario history. Her publications include *Old Clothes, New Looks: Second Hand Fashion* (2005) and *Fashion: A Canadian Perspective* (2004), as well as contributions to the exhibition catalogues *RRRIPP!! Paper Fashion* (Benaki Museum, Athens, 2007), *Christian Dior et le Monde* (Musée Dior à Granville, 2006) and *Un Secolo di Moda* (Villa Medici, Rome, 2003).

Sonnet Stanfill is Curator of Twentieth-Century and Contemporary Fashion at the V&A. She curated the V&A display *Ossie Clark* (2003) as well as *New York Fashion Now* (2007), for which she also edited the accompanying book. She has contributed to *Fashion's World Cities* (2006) and *The Fashion Reader* (2007).

Abraham Thomas is Curator of Designs at the V&A. He was curator of *Paper Movies: Graphic Design and Photography* at Vogue and Harper's Bazaar, *1934–1963* (2007). He co-curated *On The Threshold: The Changing Face of Housing* (2006) and *Alternating Currents*, a V&A season of events looking at Islamic architecture (2005).

Hugo Vickers wrote the authorized biography of Cecil Beaton (1985), and also edited two volumes of Beaton's diaries, *The Unexpurgated Beaton* (2002) and *Beaton in the Sixties* (2003). He serves as Cecil Beaton's Literary Executor, and has lectured about Beaton in England, Europe, Australia and the US. His most recent major work is a biography of the Queen Mother, *Elizabeth, The Queen Mother* (2005).

Claire Wilcox is Senior Curator of Twentieth-Century and Contemporary Fashion at the V&A and curator of the exhibition, *The Golden Age of Couture: Paris and London 1947–1957* (2007). She curated the V&A's major exhibitions *Vivienne Westwood* (2004), *Versace at the V&A* (2002) and *Radical Fashion* (2001) and edited the accompanying books. She also devised the V&A's *Fashion in Motion* series which has been running at the Museum since 1999. Other publications include *Bags* (1999) and, with Valerie Mendes, *Modern Fashion in Detail* (1998).

Acknowledgements

THIS PUBLICATION, which accompanies the V&A's major exhibition, *The Golden Age of Couture: Paris and London 1947–1957*, has been made possible with the assistance and support of a great number of people.

I would especially like to thank the Assistant Curator, Eleri Lynn, for her tremendous dedication, enthusiasm and support. Eleri and I have worked very closely together to realise this book and exhibition, and collaborated with staff across the Museum.

Firstly, I would like to thank the Director of the V&A, Mark Jones, for his support of new acquisitions that have enhanced both the exhibition and the permanent collection. I am immensely grateful to colleagues who have shared their expertise with us, in particular Lesley Miller and Christopher Breward. Special thanks are due to Christopher Wilk, Sarah Medlam, Sonnet Stanfill, Sue Prichard, Suzanne Smith, Daniel Milford-Cottam and Louisa Collins of the Department of Furniture, Textiles and Fashion, and also to Alexia Bleathman, Clare Phillips and Abraham Thomas, whose advice on twentieth-century photography was invaluable. I would like to thank the staff of the Collections Services and Conservation departments, especially Richard Ashbridge, Matthew Clarke, Robert Lambert, Sandra Smith and Nick Umney.

Presenting an exhibition and book with such a predominance of V&A objects would not have been possible without the skill, patience and enthusiasm of the staff of the V&A Textile Conservation Studio: Cynthea Dowling, Lara Flecker, Frances Hartog, Marion Kite, Roisin Morris, Debbie Phipps and Natalia Zagorska-Thomas. Thanks to Ken Jackson of the V&A Photographic Studio for accommodating all our urgent requests, and to Richard Davis for his beautiful photography. From the departments of Exhibitions, Design, Press, Marketing, Development, Learning and Interpretation and V&A Enterprises, many thanks are due to: Amelia Calver, Olivia Colling, Annabelle Dodds, Jane Drew, Kat Herve-Brazier, Poppy Hollman, Debra Isaac, Abigail Jones, Annabel Judd, David Judd, Abbie Kenyon, Jane Lawson, Cathy Lester, Linda Lloyd Jones, Nicole Newman, Lucy Trench, Lisa Smith, Rebecca Smith, Rebecca Ward, Damien Whitmore and Cassie Williams. I would also like to acknowledge the valuable contributions of Danielle Sprecher, Latoya Lee and Charles Villeneuve de Janti. Many thanks to Carolyn Sargentson and all those within the Research department, for providing the supportive environment in which this project could come to life.

My sincere thanks to our Exhibitions team, Stephanie Cripps and Elodie Collin. For their creative exhibition design, I am grateful to Land Design Studio: Robin Clark, Peter Higgins, Simon Milthorp and Jona Piehl, and to Lol Sargent of Studio Simple. Thanks also to Mike Cook of DBA and Mark Greenway and Jamie Kessack of Greenways for managing the project.

I am also indebted to colleagues in the international museum community for opening up their collections and archives. I wish to thank the following people: Rosemary Harden and Eleanor Summers at the Museum of Costume, Bath; Edwina Ehrman and Nickos Gogolos at the Museum of London; Joanna Marschner at Kensington Palace; Dr Miles Lambert at the Gallery of Costume, Platt Hall; Clare Lamkin at the Bradford College Textile Archive; Sandrine Bachelier, archivist at Bucol-Holding Textile Hermès; Beatrice Salmon, Pamela Golbin, Caroline Pinon, Marie-Helene Poix and Eric Pujalet-Plaà at the Musée de la Mode et du Textile; Catherine Join-Diéterle, Laurent Cotta, and Sylvie Lécallier at the Musée de la Mode de la Ville de Paris; Miren Arzalluz, Aberri Olaskoaga Berazadi, Mariano Camio and Igor Zubizarreta at Fundación Cristóbal Balenciaga; Betty Long-Schleif at the Maryhill Museum of Art; Andrew Bolton and Shannon Bell Price at The Costume Institute, The Metropolitan Museum of Art; the National Trust, for allowing us access to Osterley House; and to Toni-Lynn Frederick of the University of Reading.

I am highly indebted to the following people for their assistance and support: John Galliano, Philippe le Moult, Olivier Bialobos and Soïzic Pfaff at Christian Dior; Marie-Louise de Clermont-Tonnere, Marika Gentil, Nathalie Guibert and Elodie Poupeau at Chanel; Sigrid Delepine at Balenciaga; Ian Garlant at Hardy Amies; Lindsay Evans Robertson; Stephen Jones; Marie-Andrée Jouve; Svetlana Lloyd; Valerie Mendes; Kerry Taylor; Hamish Bowles; Frederic Bourdelier and Vincent Leret at Christian Dior Perfumes; June Kenton and Laure Day at Rigby and Peller; Elaine Sullivan, Ines de la Fressange and Bruno Frisoni at Roger Vivier; Geoffroy Medinger at Van Cleef and Arpels; François Broca at the Ecole de la Chambre Syndicale de la Couture Parisienne; and to La Droguerie, Paris.

Very special thanks are extended to Hubert de Givenchy, François Lesage and Percy Savage, who shared their memories with us. I am also grateful to the family of Lady Alexandra, in particular Mrs Xenia Dennen, for allowing us to study her mother's personal papers and photographs. I would like to thank Lady Thomas of Swynnerton, the Dowager Duchess of Devonshire, Lady Diana Herbert, Mrs Virginia Surtees, and the Sekers family for their generosity and kind assistance in helping to identify the recent V&A acquisition, 'Zemire' by Christian Dior.

Special thanks are due to the V&A Publications team, in particular Mary Butler, Monica Woods, Asha Savjani, Clare Davis and Geoff Barlow, and to copy-editor Catherine Blake and book designer Nigel Soper.

I would like to express my gratitude to all those who contributed to the book (listed opposite), whose expertise and knowledge have enriched this publication, and the accompanying exhibition. To those many couturiers who made the 'Golden Age' what it was, I can only express my admiration.

Thanks, as always, to my family.

CLAIRE WILCOX

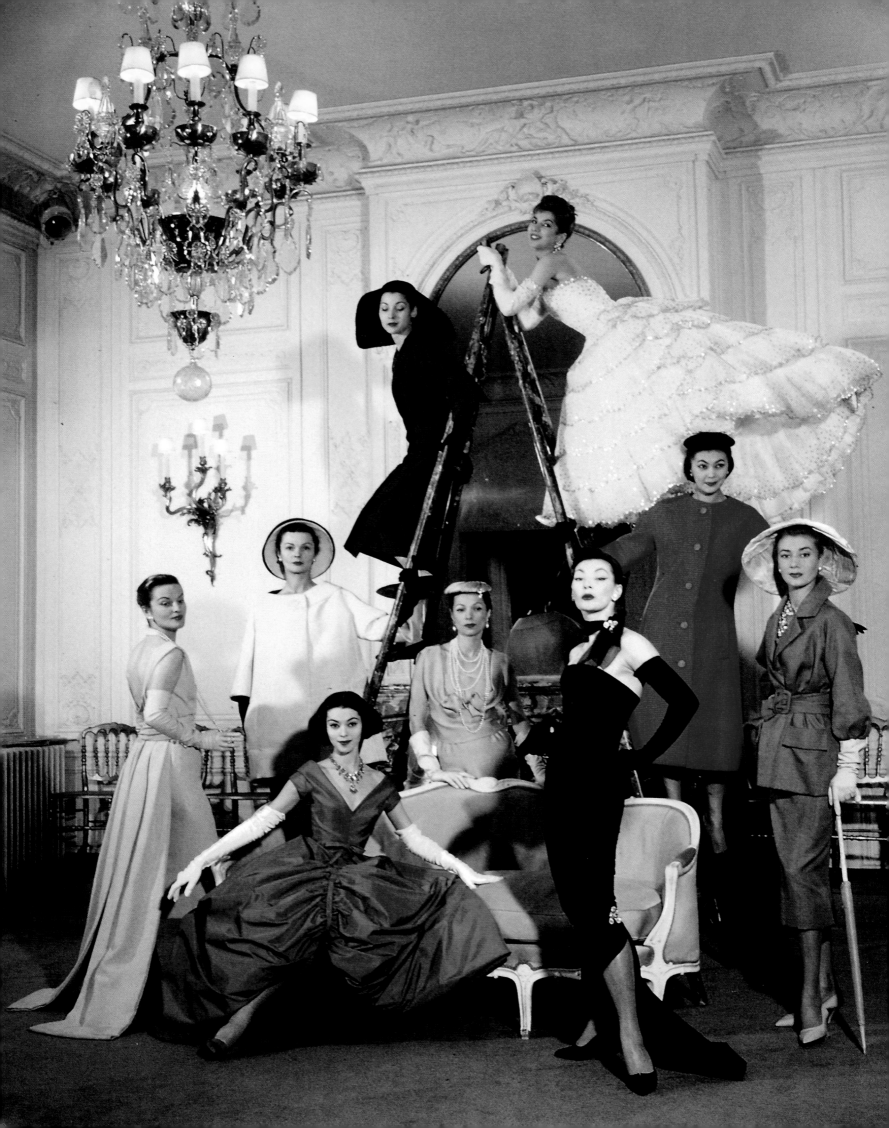

Foreword

The Golden Age of Couture: Paris and London 1947–1957 celebrates an important decade in fashion history that began with the launch of Christian Dior's famous New Look in 1947 and ended with his death in 1957. Couture thrived during these years, and Paris enjoyed renown worldwide for the luxurious creations that its fashion houses produced. Designers such as Cristóbal Balenciaga, Pierre Balmain and Hubert de Givenchy dominated the headlines but their London counterparts such as Hardy Amies, John Cavanagh and Norman Hartnell also excelled.

The V&A possesses one of the finest collections of fashionable dress in the world and we are proud to be able to feature evening gowns, cocktail dresses and suits by many of the leading designers of the time, accompanied by fashion photography and illustration from our own superb archive. Indeed, 95% of the exhibits come from the V&A's own collections. They have been specially conserved and photographed for this exhibition and book, and carefully displayed to accentuate the meticulous handcraft that each custom-made piece required.

Many of the Museum's most significant couture garments were acquired by Cecil Beaton for his exhibition at the V&A, 'Fashion: An Anthology' (1971). Sourced from the high society of the day, including members of the royal family, they provide a unique window onto post-war Paris and London couture. The V&A's Director at the time, John Pope-Hennessy, called the collection an 'incomparable enrichment of the Museum's resources'. New acquisitions for this exhibition – including a striking evening ensemble by Dior and a blue silk cape by Givenchy, identical to that worn by Audrey Hepburn in the 1957 film *Funny Face* – add to our understanding of the golden age of couture, and testify to the fruitful relationship between the V&A's exhibitions programme and the enhancement of the permanent collection.

Christian Dior described the post-war years as a 'golden age', and this exhibition recognizes his central contribution to the era. Dior and his contemporaries set the highest of standards for creative design and impeccable workmanship and their legacy continues to this day.

MARK JONES
Director of the Victoria and Albert Museum

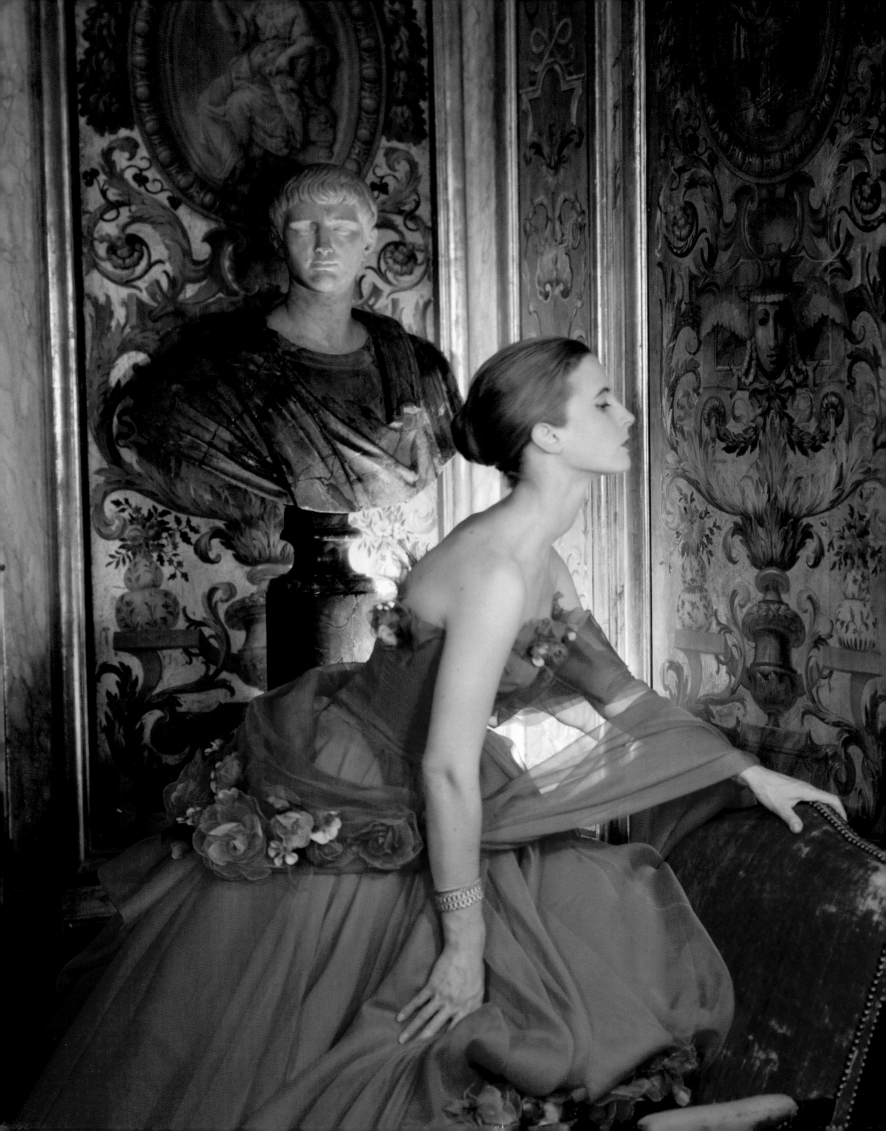

1

INTRODUCTION

CLAIRE WILCOX

1.1 Photograph by
Cecil Beaton, 1953

'*The model he imagines is, first and foremost, a beautiful object, excellently made and finely sewn; so that if, years afterwards, it were discovered at the back of some cupboard, although the fashion which inspired it has long gone out of date, it would still inspire astonishment.*'[1]

CELIA BERTIN

THE SUBJECT OF THIS BOOK IS COUTURE 'excellently made and finely sewn' in Paris and London between 1947 and 1957. This was the zenith of French couture, when designers such as Cristóbal Balenciaga, Pierre Balmain and Jacques Fath dominated fashion, and headlines in New York were held for the latest news from Paris. However, in the history of fashion, this decade belongs to Christian Dior, for he launched his new house in 1947 with the defining 'New Look' and died 10 years later, having created one of the most successful fashion houses of the twentieth century.

Paris was renowned worldwide as the centre for the creative design and skilful production of luxurious high fashion. It was founded on a system established by the British-born dressmaker Charles Frederick Worth, who opened his prestigious fashion house in Paris in 1858 with the aim of unifying design and fabrication under one roof. Almost entirely a handcraft industry, the production of couture was based on a division of labour, with separate in-house workshops for dressmaking ('*flou*') and tailoring ('*tailleur*') supported by a luxury trade in trimmings and accessories supplied by specialist ateliers all over France. Feathers, floral accessories, embroidery, beading and ribbon work were created by hand in small workshops, much as they had been since the eighteenth century, while entire streets were devoted to glove makers, shoe makers and furriers. The poet Stéphane Mallarmé described Paris at the turn of the century as

1.2 Evening dress by Rahvis. Grosvenor Square, London. *Vogue* (British edition), June 1947. Photograph by Clifford Coffin

as through the couturier's sketch and the impressions of the professional image-makers. The soft pastels of Christian Bérard, René Gruau and Eric (Carl Erickson) typified the style of fashion magazines of the late 1940s, which prioritized mood over accuracy, while the lucid quality of Richard Avedon's and Irving Penn's photography mirrored the sharp silhouettes of the following decade. Key journals of the day, such as *Vogue* and *L'Officiel de la Mode et de la Couture*, covered every couture collection and fashion magazines played an increasingly important role in introducing new styles to the growing mass audience (pl.1.8). The selection of a dress for the front cover could increase sales dramatically and this growing interdependence between fashion photography and publishing was acknowledged by Carmel Snow, editor-in-chief of American *Harper's Bazaar*, who reflected: 'The editors must recognize fashions while they are still a thing of the future. The dressmakers create them, but without these magazines, the fashions would never be established or accepted.'[27]

1.8 *Vogue* (British edition), January 1952. Photograph by Clifford Coffin

Couture differed from ready-to-wear in many aspects, but its distinguishing characteristic was that each garment was a one-off, made from start to finish by a particular workshop which derived great pride in its creation. However, once shown, the garment was subjected to photographic sessions and daily presentations until the next collection began, and, once out of date, might be sold as an ex-model at a reduced price. Most couture garments exist as versions of the original, chosen and amended to perfectly fit the private client's shape and needs. In 2006, the V&A acquired a striking evening ensemble of jacket, skirt and bodice, found in a damp cellar by the Seine – an interpretation of Dior's 'Zemire' from the Autumn/Winter 1954–5 'H-Line'.[28] A plethora of labels give clues about its identity and history and include a hand-written tape indicating that the dress was made for the wife of the leading British textile manufacturer Miki Sekers (pl.1.9). This was clearly a special order, for the startlingly bright cellulose acetate fabric was advanced for its time. Descendants of the Sekers family recall that Agota Sekers was often persuaded to commission clothes that would publicize the company's innovative fabrics.[29] An image in the Dior archive demonstrates that the original outfit – in silver-grey satin by Brossin de Méré with mink-trimmed cuffs – was one of the selection presented to Princess Margaret at Blenheim Palace in 1954.[30] A postage stamp sized piece of the fabric survives on the couture house chart which also documents its maker (Christiane) and the model who wore it (Renée). Interestingly, 'Zemire' was not only an important design which received at least one private client commission, but was also

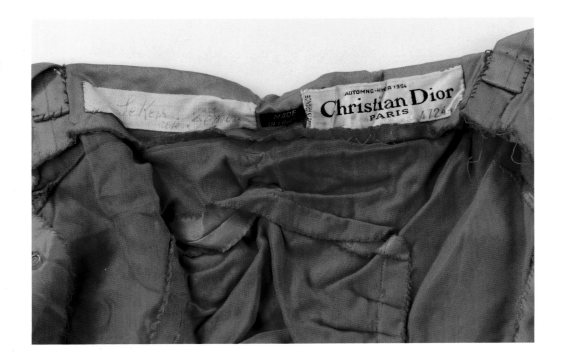

1.9 Interior of bodice showing silk lining and labels, 'Zemire'. Christian Dior, Autumn/Winter 1954–5. V&A: T.24–2007

successful in terms of commercial reproduction – it can be fleetingly glimpsed in some seconds of promotional film produced by Dior in 1954, and was featured in several magazines. An advertisement in *Vogue* (British edition) in November 1954 shows an identical copy of the skirt and bodice (without jacket) by the British ready-to-wear company Susan Small, priced at 22 guineas (pl.1.11).[31] Christian Dior also created designs for the theatre and an outfit made for Vivien Leigh by Angels & Bermans, the theatrical costumiers, bears a striking resemblance.[32] Zemire is one of Dior's most consciously historical designs. The 'riding' jacket and full skirt have a distinctly eighteenth-century flavour, and are made using traditional construction techniques. Edna Woolman Chase, editor-in-chief of American *Vogue* from 1941 to 1952, said of Dior: 'His clothes gave women the feeling of being charmingly costumed; there was a faintly romantic flavour about them.'[33] The attraction and paradox of Dior and many of his contemporaries is that although they established a modern identity for couture between 1947 and 1957, its practice and philosophy were rooted in the past.

The chapters in this book map the creative, economic and social forces that shaped couture after the war. Two images, from London and Paris, illuminate something of its status. In his salon, Jacques Fath puts the finishing touches to his elegant wife's outfit, while a floor polisher skates over the wooden floor (pl.1.13). In the second, a Hartnell model in full evening dress stands motionless while a figure in the background wields a vacuum cleaner (pl.1.14). These juxtapositions reflect the paradoxical yet perfect construct of couture, for the production and sale of luxury fashion relied on a clear division between elite and non-elite. However, while couture remained unattainable for most people – the closest they came to it was in glossy magazines or on the silver screen – the sale of ideas and an increasingly powerful media created a ripple effect that engaged and captivated an ever-growing audience. Even the BBC capitulated just

1.10 'Zemire' by Christian Dior, shown without jacket, modelled by Nancy Berg. *Vogue* (French edition), September 1954. Photograph by Clifford Coffin

Overleaf
1.11 Ready-to-wear copy of 'Zemire' by Susan Small. Silk satin. *Vogue* (British edition), November 1954

1.12 'Zemire' modelled by Dior house model Renée. Paris, 1954. Photograph by Regina Relang

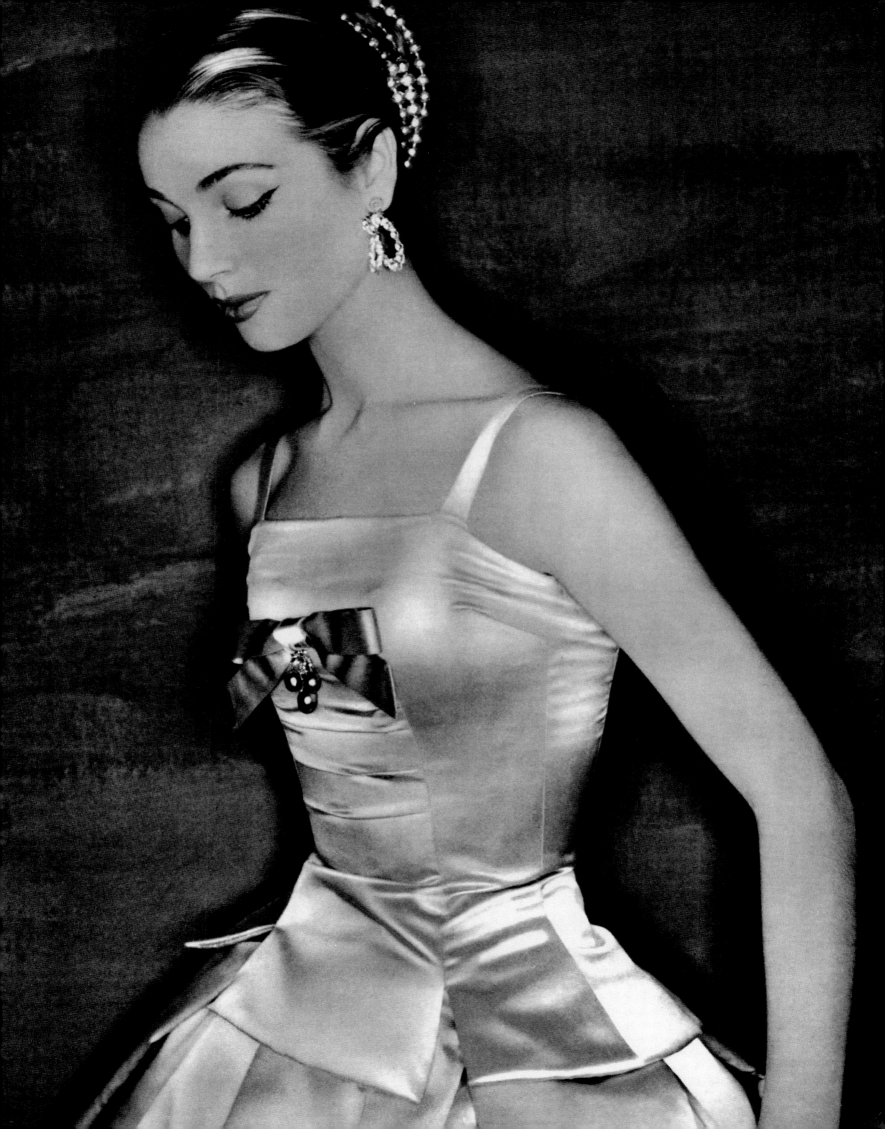

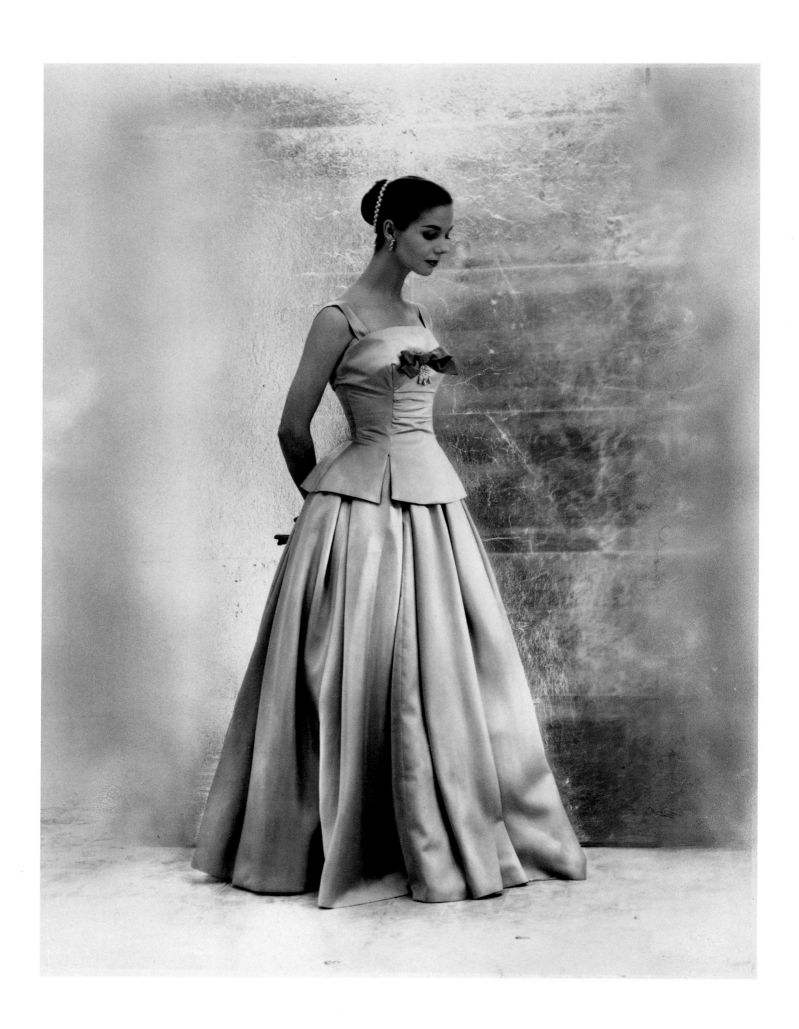

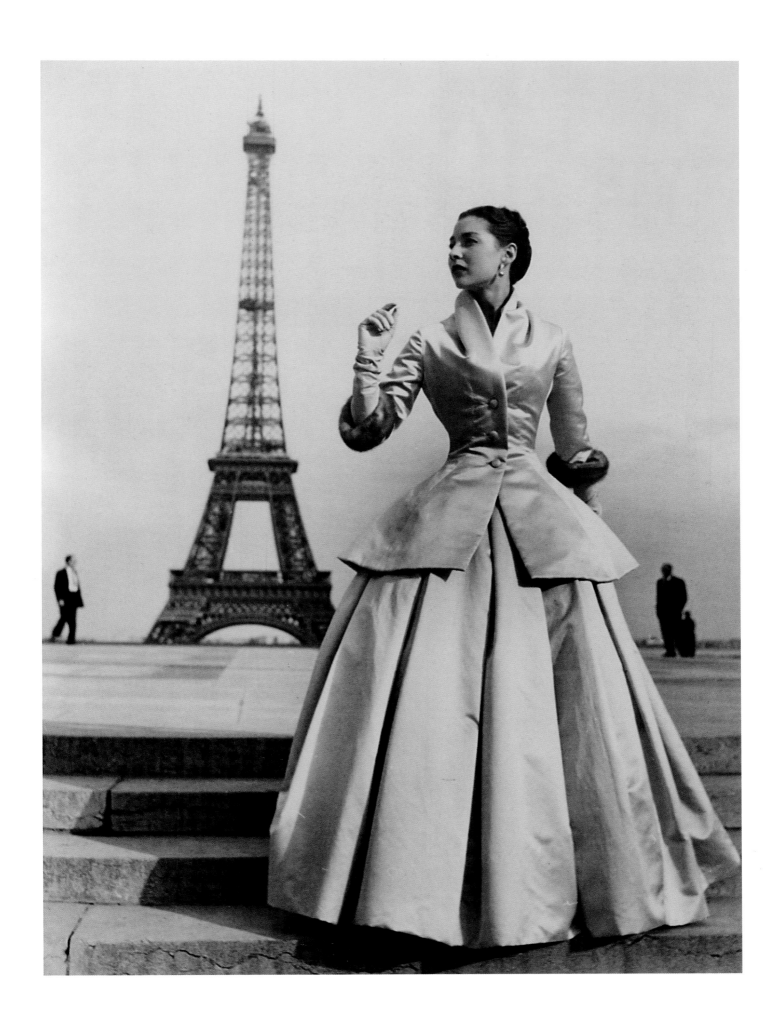

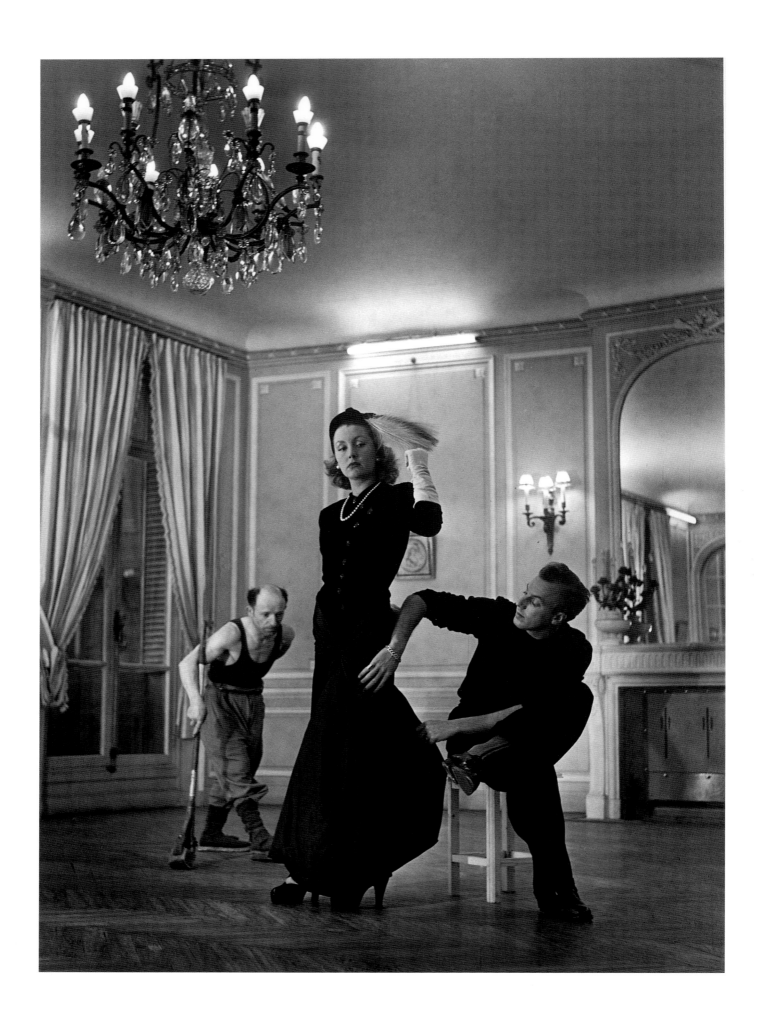

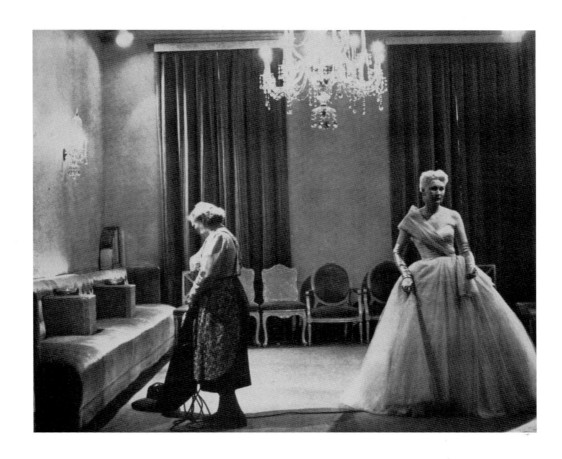

1.13 Jacques and Geneviève Fath, 1946

1.14 Lana, a house model at Norman Hartnell, February 1955

after the war, with a television series devoted to the great French couturiers, presented by V&A curator and historian James Laver.

Although cultural and economic changes in society in the 1950s and the changing patterns of consumption eventually displaced couture, its fragile existence today remains a symbolic if not financially profitable commitment to personal aspiration, national identity and extraordinary and time-consuming handcraft. Its legacy is clear in modern fashion which, faithful to fashion's eternal preoccupation with both past and future, frequently mirrors the styles and manners of this elegant age.

This book is published in conjunction with the exhibition 'The Golden Age of Couture: Paris and London 1947–1957' at the V&A (22 September 2007–6 January 2008).

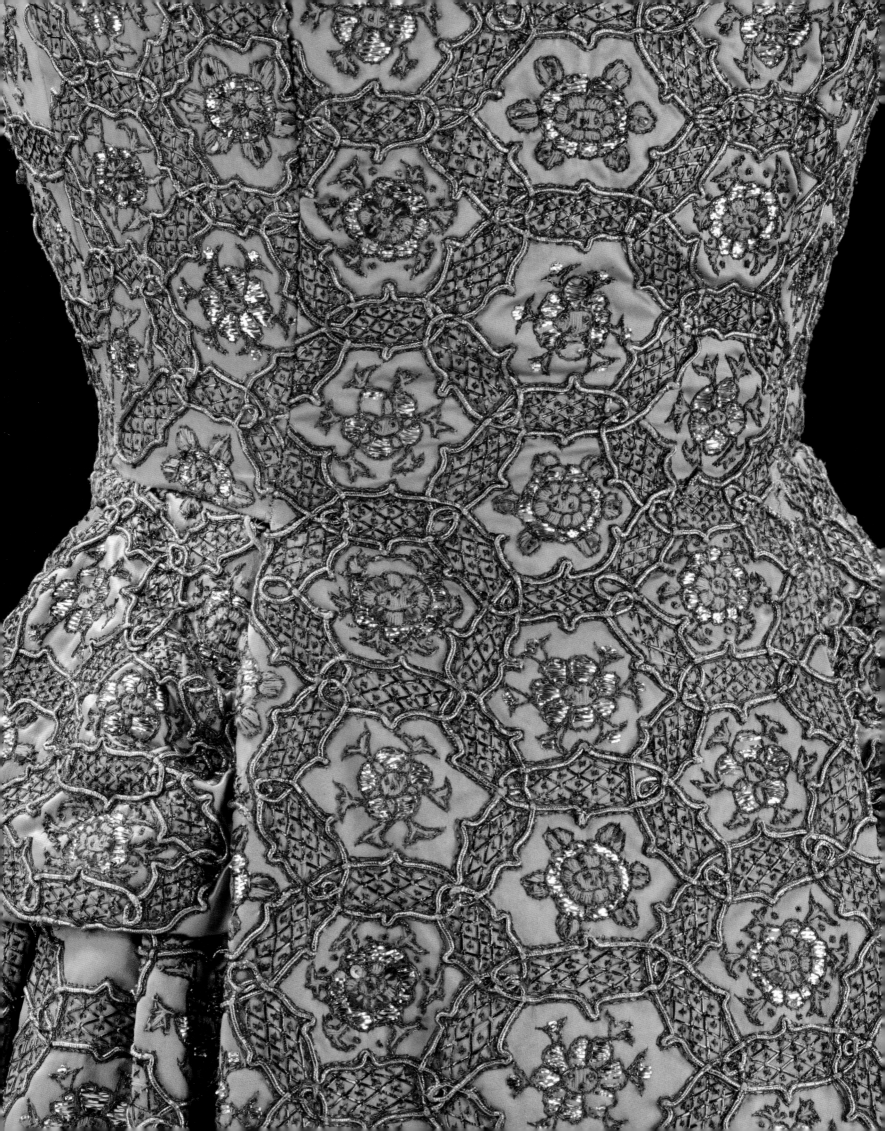

2

DIOR'S GOLDEN AGE
The Renaissance of Couture

CLAIRE WILCOX

'A golden age seemed to have come again. War had passed out of sight and there were no other wars on the horizon. What did the weight of my sumptuous materials, my heavy velvets and brocades, matter? When hearts were light, mere fabrics could not weigh the body down.' [1]

CHRISTIAN DIOR

PARIS WAS THE UNDISPUTED CENTRE of fashion in the years leading up to the Second World War. In 1937, there were numerous haute couture houses, among them the grand establishments of Chanel, Lanvin, Lelong, Mainbocher, Molyneux, Patou and Schiaparelli, as well as newcomers Jean Dessès, Jacques Fath and Cristóbal Balenciaga. The ebb and flow of seasonal fashion collections drew an international audience of wealthy private clients from Europe, the United States and South America (an increasingly important market), who arrived every season to commission new wardrobes. Equally important were the professional buyers who flocked to Paris, eager to pick up ideas and buy the latest fashions for reproduction across the world. However, the Second World War and the occupation of Paris by German troops between 1940 and 1944 disrupted the economy of haute couture and threatened its survival. In 1946, while Paris fashion was still struggling to recover, Christian Dior launched his new house on avenue Montaigne and became an overnight sensation with his first collection: 'unknown on the 12th of February, 1947, famous on the 13th,' wrote *L'Express*. [2]

Although a good number of houses had survived the war, and a few even opened during it, such as Marcelle Chaumont in 1940, Dior was regarded by many as the saviour of haute couture. His romantic vision created a mood of optimism after the gloom of the previous years, while the complex artistry of his gowns drew on skills unique to Parisian couture, providing employment for numerous *premières* (atelier supervisors)

and seamstresses. For a decade Dior's collections, with their endless supply of ideas, provided headlines and fuelled the growing market in ready-to-wear, particularly in the US, while still maintaining Paris's traditional status as a creative source for innovative fashion. This chapter traces couture's revival in the post-war period in the context of Dior's brief but immensely influential reign.

Paris 1939–45

Just days before the outbreak of the Second World War the weekly US magazine *Time* informed its American readers that 'reports from the opening of Paris fashion shows have grated on Nazi ears for the past fortnight as Schiaparelli followed Mainbocher, and Paquin, Patou and Balenciaga demonstrated that, whoever runs the world, Paris intends to go on making his wife's clothes (pl.2.3).'[3] The couturiers' defiance was a question of both national pride and economic necessity, and reflected an underlying concern about control of the fashion markets, threatened as they were by the storm clouds on the horizon. Within months of the outbreak of war, travel restrictions began to affect overseas orders as fewer international buyers attended the collections and private clients began to disperse. Edna Woolman Chase, who was editor-in-chief of American *Vogue* from 1941 to 1952, wrote in her memoirs: '*Vogue*'s role in the first few months of war was a gratifying if complex one. The couture suddenly became strangely dependent on us. The most cogent questions from the Paris office were: 'How does the wind blow on Seventh Avenue? Are the wholesalers profiting by war to push American design?'[4] This anxiety was not unjustified. Cecil Beaton noted in his diary how horrified he was that Paris's fall to the Germans was hailed with delight by the American press 'as a means of getting at Paris fashions quick'.[5]

Although the September 1940 issue of American *Vogue* cried 'What will America do without Paris fashion?',[6] home-grown designers such as Hattie Carnegie, in tune with New World sensibilities and the desire for informal, youthful styles, were gaining confidence and saw an opportunity to challenge French dominance of the lucrative and expanding ready-to-wear market. In terms of production France could not compete, for the US was now an industrial giant, mass-producing clothing as well as cars. Paris's strength was in innovative design, but as the war progressed several important designers relocated to New York until the war was over, upsetting the established balance of power. The American-born Mainbocher, couturier and former editor-in-chief of French *Vogue*, set up on 57th Street next to Tiffany's, stating 'America was working hard to make New York the world centre of fashion,'[7] while British journalist Alison Settle remembered: 'They had French émigré couturiers like Schiaparelli to help them.'[8]

By 1941 ration cards had been introduced in Paris as clothing shortages increased, caused by German requisitions and the difficulty of transporting supplies between the occupied and unoccupied French territories. Home dressmaking and couture were both hampered by lack of supplies, from thread to pins, scissors and needles. In March 1943

2.3 Ensemble by Cristóbal Balenciaga. Paris, 1941. Photograph by Seeberger

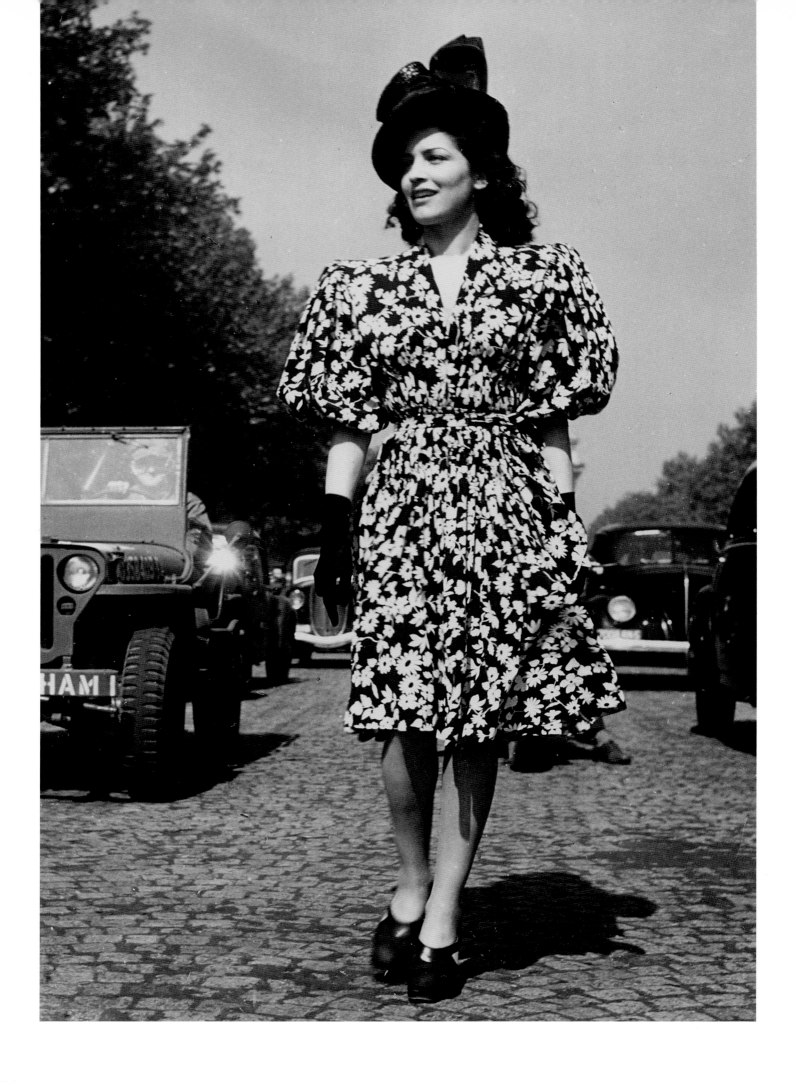

British *Vogue* published an article entitled 'How we live in France' by Elizabeth Hoyt, an American living in Paris, which stated that 'clothing rations are so meagre that it is impossible to dress comfortably – or even adequately – without recourse to "Black Markets" at enormous prices. Fortunately I had a pre-war wardrobe and have been gradually wearing this to shreds.'[9] The historian Dominique Veillon described how, in the face of dwindling overseas visitors, the Chambre Syndicale encouraged French women to continue to buy couture, with publicity drives in the press that defended couture's cultural importance, arguing that 'stylishness was an economic weapon'. A ration card was issued for couture clients and buyers, and a limited number of authorized couture houses were given an allowance of materials, while regulations were imposed on the number of designs produced. Some couturiers, such as Balenciaga and Grès, continued to make elaborate evening gowns in defiance of restrictions and were temporarily closed down. Some responded to the new conditions of war with practical outfits for cycling and travelling by metro.[10]

Post-war Paris

Paris's liberation in August 1944 abruptly exposed its wartime fashions to the world press (pl.2.4). Much was made of the cyclists' outfits and extravagant hats. As the first sightings began to emerge, *Time* magazine reported 'poke bonnets of brilliant-coloured straws, some 18 inches tall'.[11] Cecil Beaton, in Paris as one of the party of Winston Churchill's 1944 official visit, noted the 'Durer-esque headgear, suspiciously like domestic plumbing, made of felt and velvet' and the 'wide, baseball-players' shoulders, and heavy sandal-clogs, which gave the wearers an added six inches in height but an ungainly, plodding walk'. He added: 'Unlike their austerity-abiding counterparts in England these women moved in an aura of perfume.'[12]

Hermetically sealed from the rest of the world for four years, French high fashion seemed extravagant to British taste, for designers such as Digby Morton and Hardy Amies had been expected to conform to Utility restrictions on fabric quantities, skirt lengths and even number of buttons. The arrival in London in 1945 of the French ambassador's wife Mme Massigli in a tight-waisted jacket, full skirt and large hat was greeted with amazement, for Londoners still looked as they had in 1939.[13] 'We have only to look at the flippant and over-lavish designs, quite out of keeping with present times, which emanated from Paris before and after its liberation to understand the advantage that the restraint of utility clothing has given to Britain,' wrote Morton.[14] In their defence, Paris couturiers argued that they made fewer dresses with the available material rather than stint on quality of design.[15] Alison Settle, one of the first correspondents to arrive in Paris after the liberation, noted that the tendency towards full skirts had been necessary to conceal the poor quality of available fabrics, such as *fibranne* (spun rayon), and to compensate for lack of raw materials for underpinnings.[16]

In the face of the barrage of disapproval aimed at anyone suspected of collaboration,

2.4 'V-day' day dress by Maggie Rouff. Paris, 1944. Photograph by Seeberger

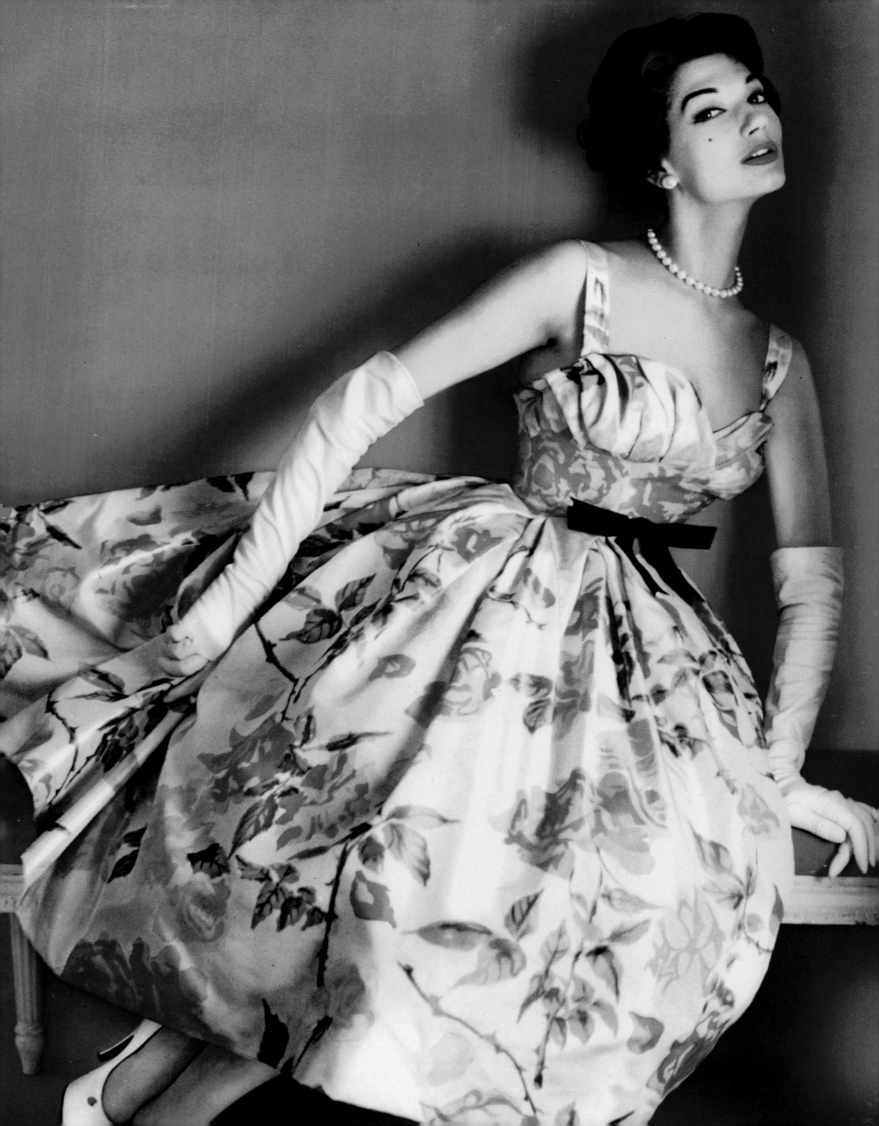

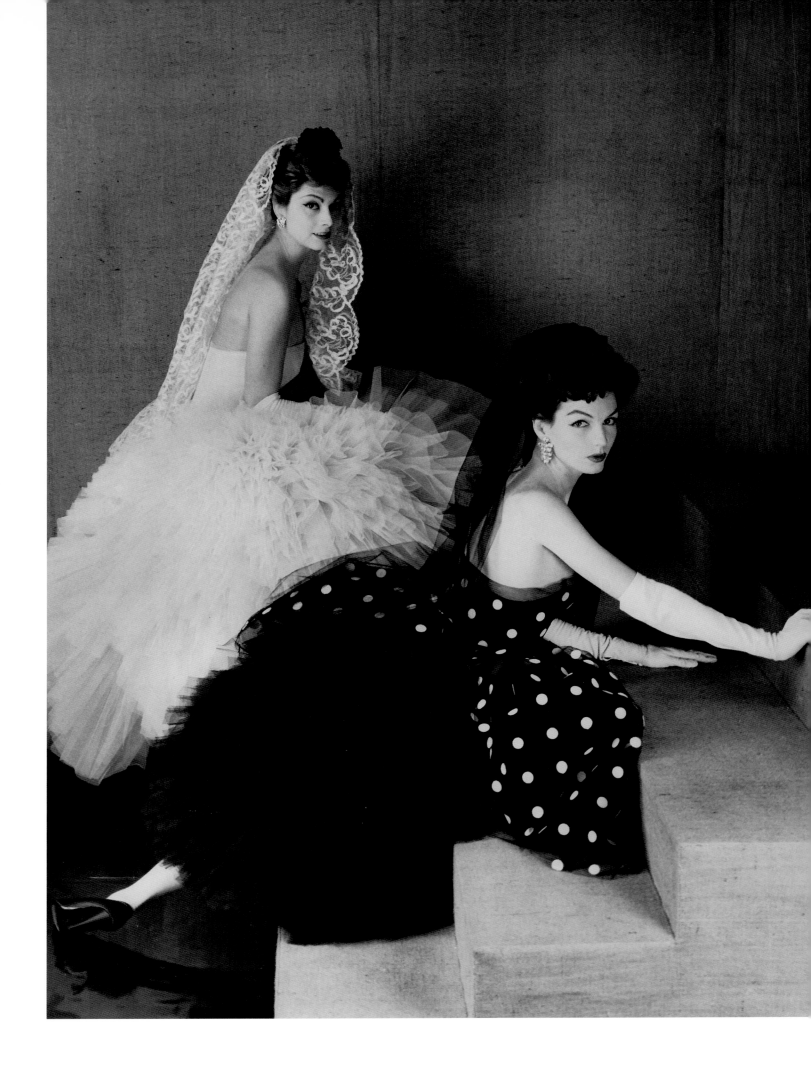

2.16 Cocktail dresses by Lanvin Castillo. *Vogue* (French edition), April 1957. Photograph by Henry Clarke. For the black and white dress, see V&A: T.52–1974

2.17 Evening dress by Digby Morton. Draped jersey, 1954. Given by Lady Howard Robertson, V&A: T.278–1975

still wore clothes made by dressmakers (although not necessarily couture) rather than ready-to-wear.[46] For Dior, custom-made dresses still accounted for over 50 per cent of his total dress sales, but *Time* magazine claimed that for every $400 dress, he made only a profit of $30;[47] in some cases, profit was abandoned totally for the sake of publicity. On 8 March 1950, Lady Gladwyn noted in her diary, 'Mme Massigli was in a tremendous Dior dress, Mme Auriol in one from Fath which I preferred; I have no doubt that neither paid for their dresses but wore them as advertisement.'[48] French employment regulations made it difficult for couturiers to cut the cost of time-consuming hand labour and the situation was compounded by the loss of Eastern European markets and a reduction in European and South American sales because of currency and import restrictions; many clients had problems during the Fifties and even into the Sixties, according to fashion publicist Percy Savage, because they could not get their money out of the country.[49] The wealthy still looked to Paris for direction but increasingly

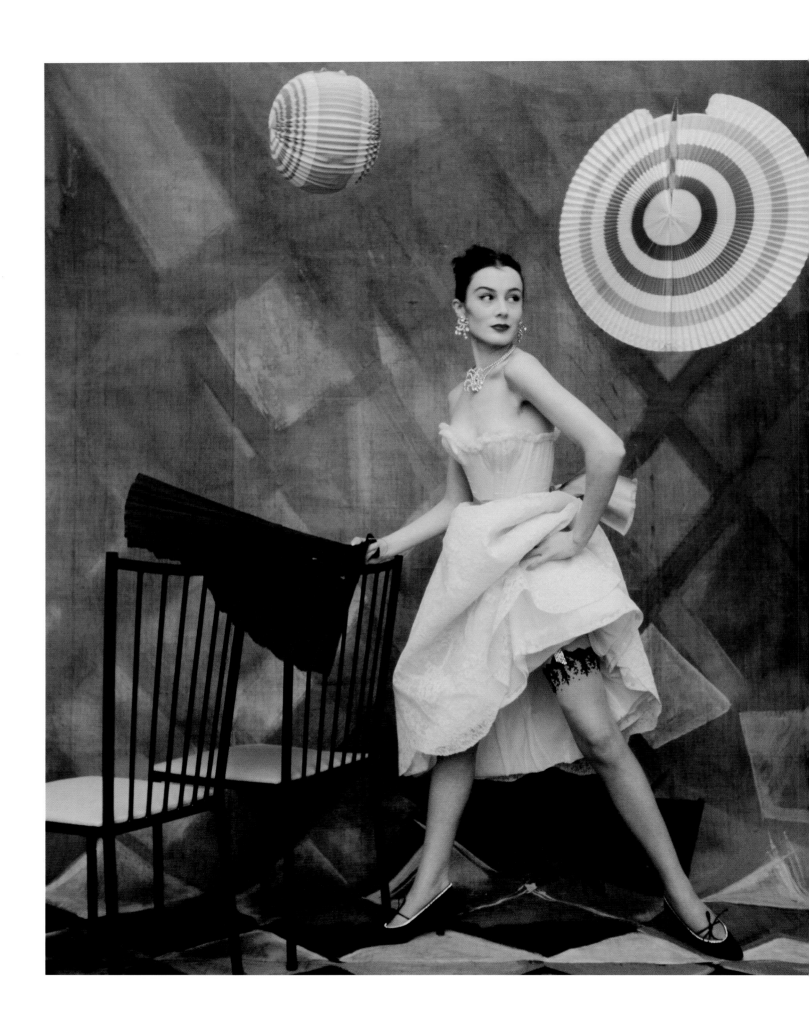

did not buy: Cecil Beaton reported that the Duchess of Argyll 'admitted her clothes are a result of inordinate care and thought, that she buys them in New York because they're better value, but goes to Paris to keep her eye in',[50] while Evangeline Bruce, one of Dior's most loyal clients, began to buy American copies of his garments. 'They were labelled "Monsieur X", but everyone knew. You couldn't tell the difference,' said one New York store executive. The issue was also one of a changing social climate; couture client Mme Fabre-Luce said: 'I couldn't face interminable fittings. Of course there was an undoubted aesthetic loss. You rarely see anyone in the street who rises above the ordinary now.'[51]

A recurring theme in all the couturiers' autobiographies of this period was the issue of intellectual copyright and uncontrolled copying. Savage described how a major client of Balenciaga 'used to come to London after she had bought from Balenciaga, and go to a little couturier in Beauchamp Place, who would copy stitch for stitch and bead for bead the jackets and suits and dresses… she told everybody that she did it, everyone knew that she had copies of them'.[52] Although copying on this level may have been tolerated if not appreciated, professionally organized plagiarism forced designers into *prêt-à-porter* in an attempt to control market forces. Savage recalls 'word would get back to the house… perhaps one unhappy manufacturer who had bought a lot would see that somebody else had used the name of Lanvin when they weren't allowed to… we would eventually speak to them, or sue the other house. That happened fairly regularly… The Americans were reasonably good, and they paid a lot of money so we let them get away with murder.'[53] Despite a law passed in 1952 that copyrighted a couture collection for one season,[54] leading couturiers filed dozens of lawsuits a year in an attempt to prevent fraud, but much of it was too complex to pursue. Settle wrote: 'Paris gave them [the buyers] the ideas and inspiration for scores of models which they did not buy but "carried in the eye".'[55]

'Avenue Pierre 1er-de-Serbie is my street in Paris, in the heart of the haute couture quarter. Seventh Avenue is its American translation into wholesale terms,' observed Jacques Fath in *Fodor's Women's Guide to Paris* in 1956. Of the same two streets, he wrote, 'the two get on fabulously well together for very sound reasons. They respect and need each other.'[56] Fath launched his house in 1937 and in 1949 'freely admitted' to have 'already sold 41 million francs worth of custom-made dresses'.[57] He was, from the American perspective, one of the three giants of post-war Paris fashion alongside Christian Dior and Pierre Balmain, although his name is less familiar today because of the closure of his house following his untimely death in 1954. Like Dior, Fath travelled to the US regularly from 1948, having branched into the American market with a ready-to-wear line with the American clothing manufacturer Joseph Halpert. The designs were sold in numerous cities in Lord & Taylor, Magnin and Neiman Marcus stores. Fath learnt quickly from the American wholesalers; his ready-to-wear line of 1953, 'Université', was backed by press and textile magnate Jean Provost and utilized mass-production and sizing methods developed in the US. Fath's versatile designs were tailor-made for the American way of life, even determining the type of materials employed: 'lightweight

2.18 Boutique stockings by Jacques Fath, 1954. Photograph by Henry Clarke

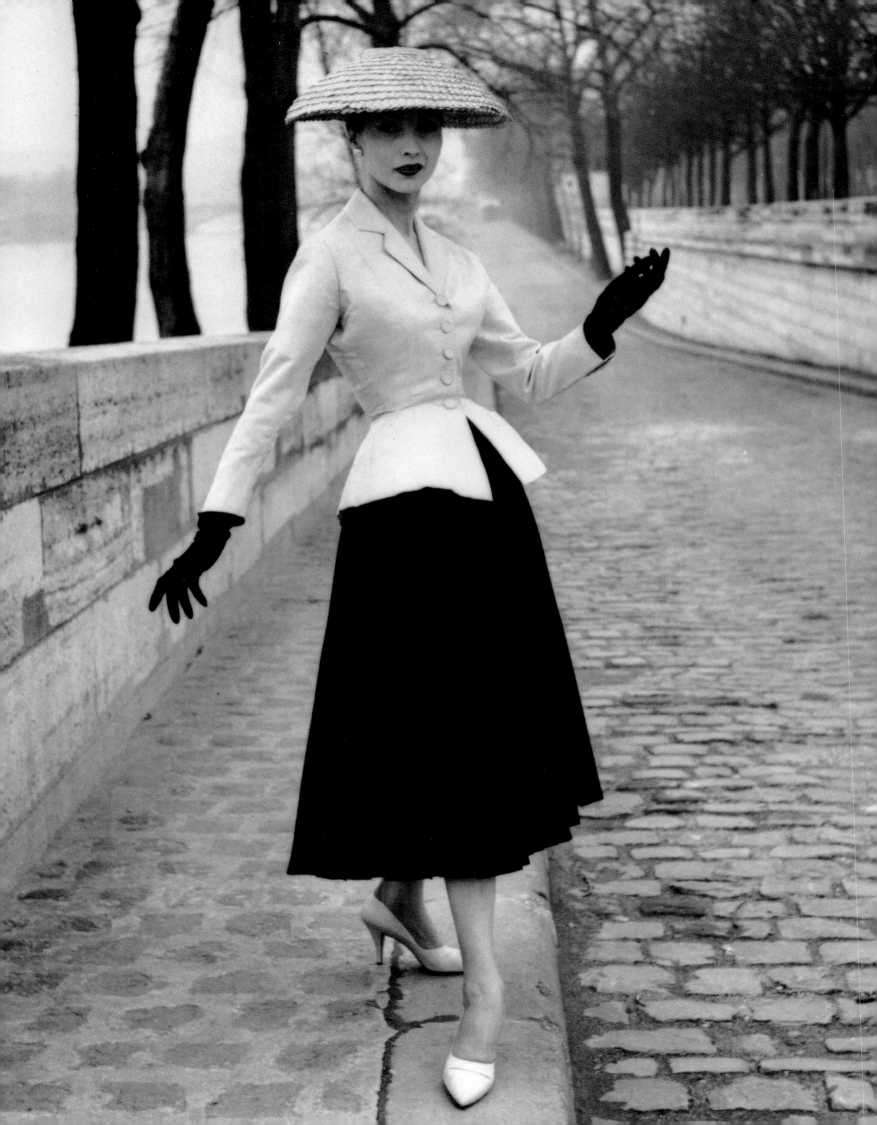

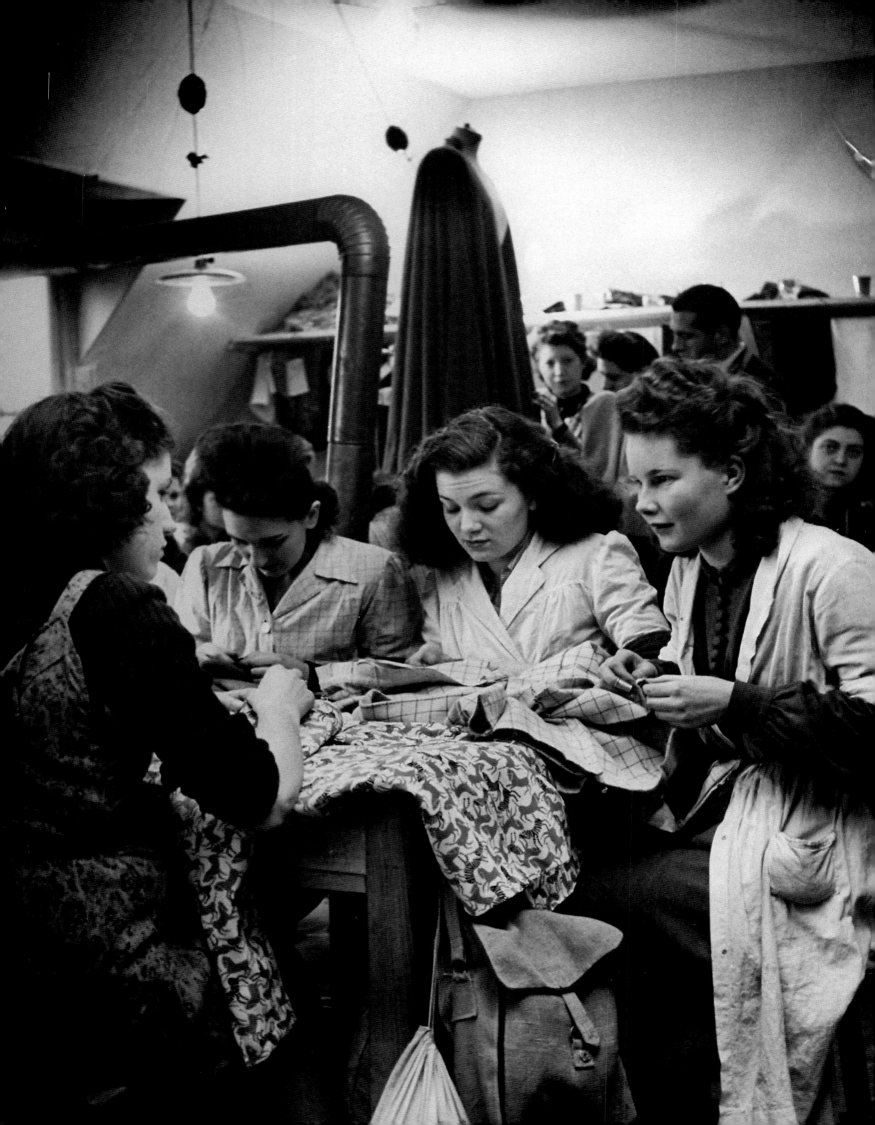

3

INSIDE PARIS HAUTE COUTURE

ALEXANDRA PALMER

'*… the rustle of silks and satins, the variegated perfumes carried thither by the clients, the murmuring voices of saleswomen and dressmakers like the droning bees and the sound of whispering from neighboring booths and smothered laughter.*'

PAUL GALLICO

'A PARIS DRESS makes one feel capable of charming a pearl out of an oyster,' wrote Jean Dawnay, a model for Christian Dior.[1] In the 1950s it was understood that fashions that bore a Paris couturier's name were impeccable in design, taste and fabrication. One client wrote: 'A dress signed by a great couturier that fits like a glove, immediately invests one with enormous self-confidence. When I wear my foulard dress I feel like an important person… nothing will alter the fact that it is a dress by the great X, and because it is by X nobody can possibly speak ill of it.'[2] Haute couture and Paris were inseparable. Yet, while the romantic associations of Paris haute couture gowns were perpetuated by clients, journalists and the couture industry itself, the actual mechanics of sustaining the luxury craft relied upon a complex infrastructure rooted in French geography and history. A close examination of the French couture system explains why and how the post-war years are recognized as the 'golden age' of Paris haute couture.[3]

The custom dressmaking business, haute couture, was formally founded in 1868 and called the Chambre Syndicale de la Couture Parisienne. This agency was a legal governing body that dealt with labour, marketing and copyright issues for individual couture houses as a collective. Membership was reviewed annually and based upon strict rules that covered location, creation, fabrication, presentation and dissemination of haute couture designs. The key concern was to protect France's historic reputation as

3.2 'Les Muguets', evening dress by Hubert de Givenchy. Organza with sequins and beads, 1955. Given by Viscountess de Bonchamps, V&A: T.223–1974

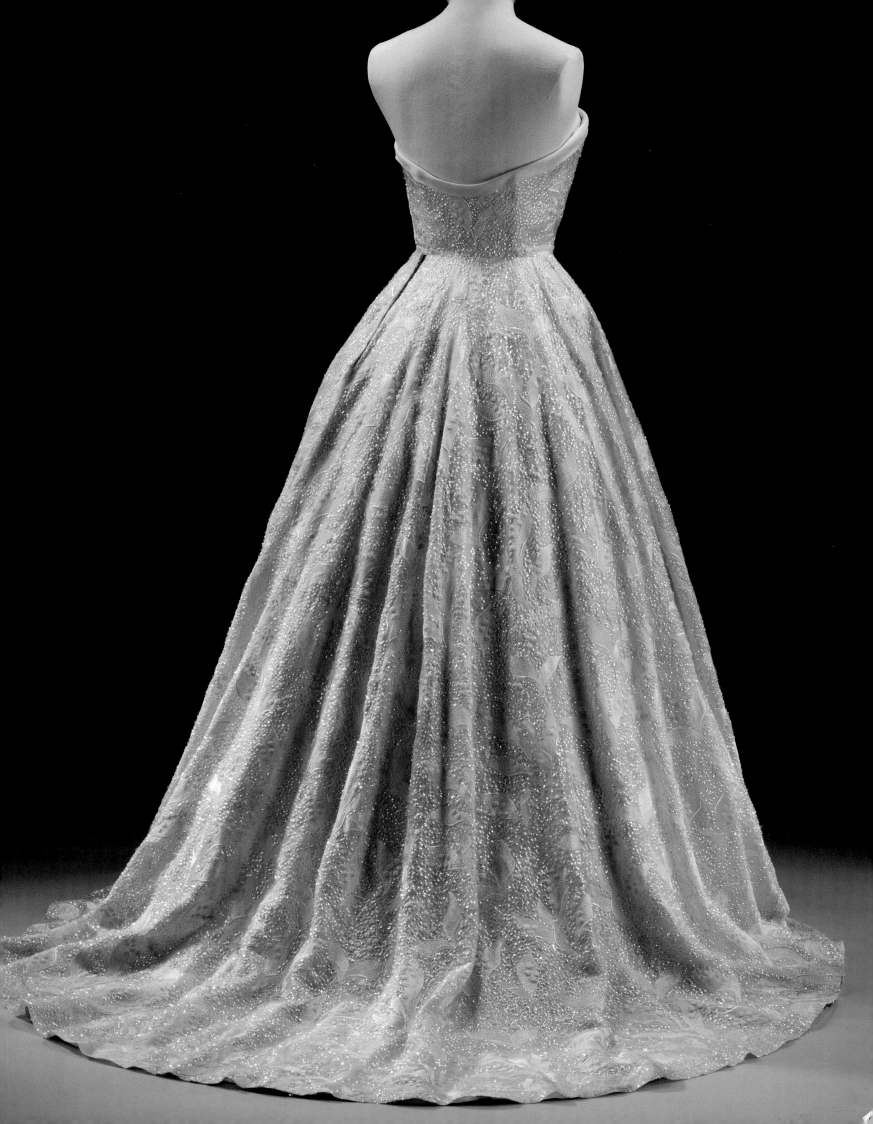

the crucible for modern, innovative and original fashion design as well as its artisanal skills. Thus, haute couture was not only an artistic oeuvre but also an important cultural product that was part of French patrimony. It was also an important business that, before the Second World War, accounted for over 300 million francs in French exports, an important point that is usually ignored in favour of more glamorous and artistic promotion.[4]

The years immediately following the war brought rapid renewal and change. The Paris couture industry was faced with the prospect of keeping alive its centuries-old traditions and skills by marrying them with the reality of a new post-war economy and changing clientele. In 1945 the Chambre Syndicale introduced new regulations that British fashion journalist Alison Settle noted were imperative, since 'you cannot divorce trade and creative art'.[5] Indeed, 'the costing of each dress is all that really matters in the final analysis… so many hours of electric light burned, so many hours of work girls' time, so many yards of material, so much for embroidery, …for the zipper, …for a button, …the wages of the man and the petrol for the van to deliver it… the cardboard boxes and the tissue paper… (masses of tissue paper)… and so on… and so on.' A Paris couture house operation was a 'strange mixture of theatre and commerce, showmanship and business'.[6]

The regulations for membership of the Chambre Syndicale applied to all aspects of the business. The couturier had to maintain 'suitable' premises in Paris. Each collection had to comprise a minimum of 75 original designs created by the couturier or by *modélistes* (assistants) who were employed full-time by the house. Collections had to be shown twice a year, in the spring and autumn, on dates set by the Chambre Syndicale. The designs had to be made-to-measure, and shown in a *passage* on three models at least 45 times a year in the Paris house. The rules also covered the technical execution of the original designs and the repetitions that had to be made to measure for clients (stipulating a minimum of three fittings at each stage). In order for the house to achieve this, it needed at least 20 full-time employees, comprising seamstresses (*petites mains*) and saleswomen (*vendeuses*). These stringent regulations help explain why opening a couture house was a complex and serious financial investment, unlike that of a custom dressmaker who could work from home and hire workers as needed, thereby reducing overheads. They ensured that haute couture retained the type of practices that could not devolve into mass production, particularly at a time when they seemed to be obsolete and in danger of disappearing.[7]

Architecture and Décor

During the late seventeenth century, the organization of French couture had been based on a successful network of luxury manufacturers and ancillary industries located in the suburbs and provinces, who produced 'textiles, beading, feathers' and included, 'shoemakers, milliners, furriers, leather merchants, makers of buttons, belts, buckles,

3.3 Gloria Swanson leaving Jacques Heim at 15 avenue de Matignon, Paris, 1955

handbags, flowers, umbrellas; purveyors of ribbons and laces and sophisticated laces; hairdressers, embroiderers, jewellers'. These trades were in constant contact with Paris merchants, who let them know what the customers were requesting and buying. A location within Paris, the traditional shopping centre of France, was essential for a true *maison de la haute couture* (pl.3.3).[8]

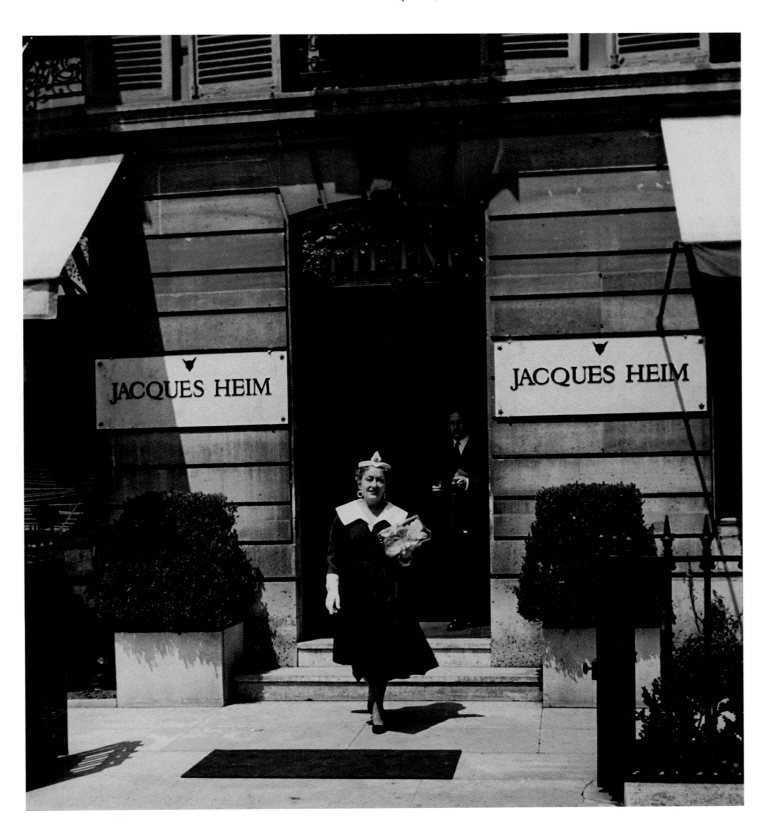

Post-war, the most fashionable address for a couture salon changed. Previously this had been the rue de la Paix, but when Alix reopened as Maison Grès, at 1 rue de la Paix, her business was described as 'the newest house on an old-fashioned street'. The newly fashionable streets emanated from the Rond Point des Champs-Elysées, and housed 'more dressmakers and milliners than any other in Paris'. Among these were the new house of Pierre Balmain, which first opened in 'two small decorated salons on an upper floor of the building at 44 rue François I – in the Georges V quarter of Paris', and Jacques Fath, whose 'swank house, formerly in a private residence' was on avenue Pierre I^{er} de Serbie. Jean Dessès's new salon on the corner of avenue Matignon and rue Rabelais was notable, since it was previously the home of Alexandre Eiffel – with 'proportions [that] reflect the tower itself', it was most impressive.[9]

A couturier had to present a collection in a fashionable, tasteful interior suitable for receiving clients who were used to luxury. Both locations and settings did not go unnoticed. The house of Manguin on place François I^{er}, for example, was reported to be indicative 'of the post-war tendency of Paris dressmakers to establish themselves in plushy residences of the nineteenth century, and to decorate them in a style that reflects the taste of the original period'. Each couturier's establishment was a deliberate expression of his or her taste. At Molyneux, a client found 'The salons… decorated in gray, are light and spacious, being meant to serve as inconspicuous settings for the clothes. These things reflect the personality of the head of the house, who has pleasant easy manners, [and] wears Savile Row clothes.'[10]

Before opening his house Christian Dior had clear ideas of what he thought would be appropriate. 'I did not want an authentic Louis XVI interior; I wanted a 1910 version of Louis XVI, a notion most [decorator friends] would have considered complete folly.' Dior hired Victor Grandpierre, who had been 'brought up in the right tradition' and who created the 'salon of my dreams: all white and pearl grey, looking very Parisian with its crystal chandelier, discreet light brackets and a profusion of quintias palms…'(pl.3.4). The business location and décor were so key to presentation and sales that the look and ambience of Paris salons were emulated internationally by department stores and luxury boutiques.[11]

However, the circumscribed setting could make rapid expansion difficult. The house of Givenchy opened in February 1952 at 8 rue Alfred de Vigny, near the Parc Monceau, with 22 employees, and by 1956 had 250. In six years the house of Christian Dior had taken over five buildings, ran 28 workrooms and needed a thousand employees to accommodate the rapidly expanding Dior empire that had begun with a single house, three workrooms and 85 staff. A Paris couture house was a unique space that united the ambience of a private residence in the salons (complete with dressing rooms for intimate fittings) with an artist's studio, workrooms or ateliers and storerooms, as well as business offices for press, financial affairs and record keeping. In this way the dual public and private faces of haute couture were housed under one roof.[12]

3.4 Christian Dior collection, February 1951, shown in the grand salon

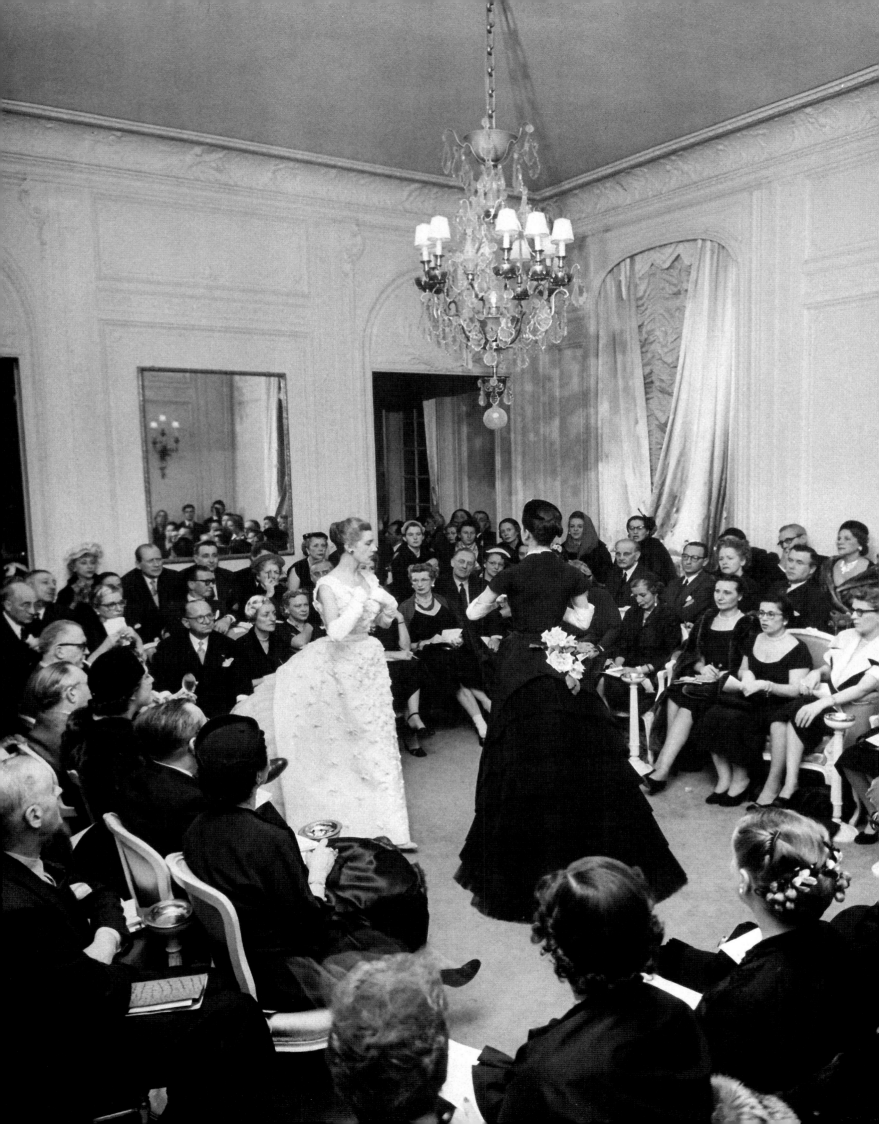

Creation within Hierarchy: Studio and Ateliers

An haute couture house was an inherently hierarchical organization that ensured fluid teamwork between the interior workings of design studio, workrooms, models and the public showing and selling of the garments in the salons. This system stemmed from French medieval guilds that were abolished during the Revolution in 1791. Historically, cutting the textile, a more potentially ruinous and expensive craft, was a skill only learned by men through apprenticeship to a tailor. Women were seamstresses or sewers and did not learn how to cut complex tailored shapes. It was not until the late 17th century that they were allowed to form their own guild and began to professionalize their trade and expand their skills, though they were still forbidden from making fitted and formal dress.[13] The hierarchy began with the couturier who was considered to be 'an artist who can be influenced in a direction which he considers to be the line of the day but who cannot be dictated to. Each of the great dress houses of Paris has at its head a man who is himself either a designer, or, as it were, the conductor of an orchestra of designers.'[14] The couturier represented the entire house and his or her name was on the label.

An haute couture garment was first and foremost the fruit of many hours of craftsmanship. The first stage was creating the *modèle* (design), either through sketching or draping cloth directly on a model (pl.3.6). Jacques Heim explained that innovation was a subtle thing: 'We do not expect the couturier to show us new dresses each season, but a conception of woman as well, for whom the dresses have been designed.'[15] A couturier could employ *modélistes* to help with the design, but could not buy outside designs, as was allowed before the war.[16] This permitted different approaches to designers in the house, as well as the continuation of the business when the founding couturier retired or died.

Once the designs were conceived the textile had to be selected and ordered from the manufacturer in the amount required (see Chapter 5). This stage was followed by the choice of buttons, trims and all findings that had to be sourced and ordered. Like a beehive, the couture house received and sent out for external suppliers. As Dior famously described, the textile producers came 'from Paris, London, Roubaix, Lyons, Milan and Zurich… bringing with them the wealth of the Low Countries and the richness of the Orient'.[17] Two months in advance of the collections the suppliers showed samples to the couturiers. Each textile manufacturer or embroidery house designed their collection in response to the current cultural sensibilities of the season, in the hope of selling between 50 and 75 per cent of their line. Once sold, the design was exclusive to that couture salon.[18] However, couturiers would often place design samples on hold while they created their collection, which meant that suppliers could not show a design to another couturier until it was firmly declined, usually at a

3.5 Part of an advertising feature sponsored by the Chambre Syndicale de la Haute Couture Parisienne. *Vogue* (French edition), February 1948

3.6 Jean Dessès in his studio, *c.* 1950

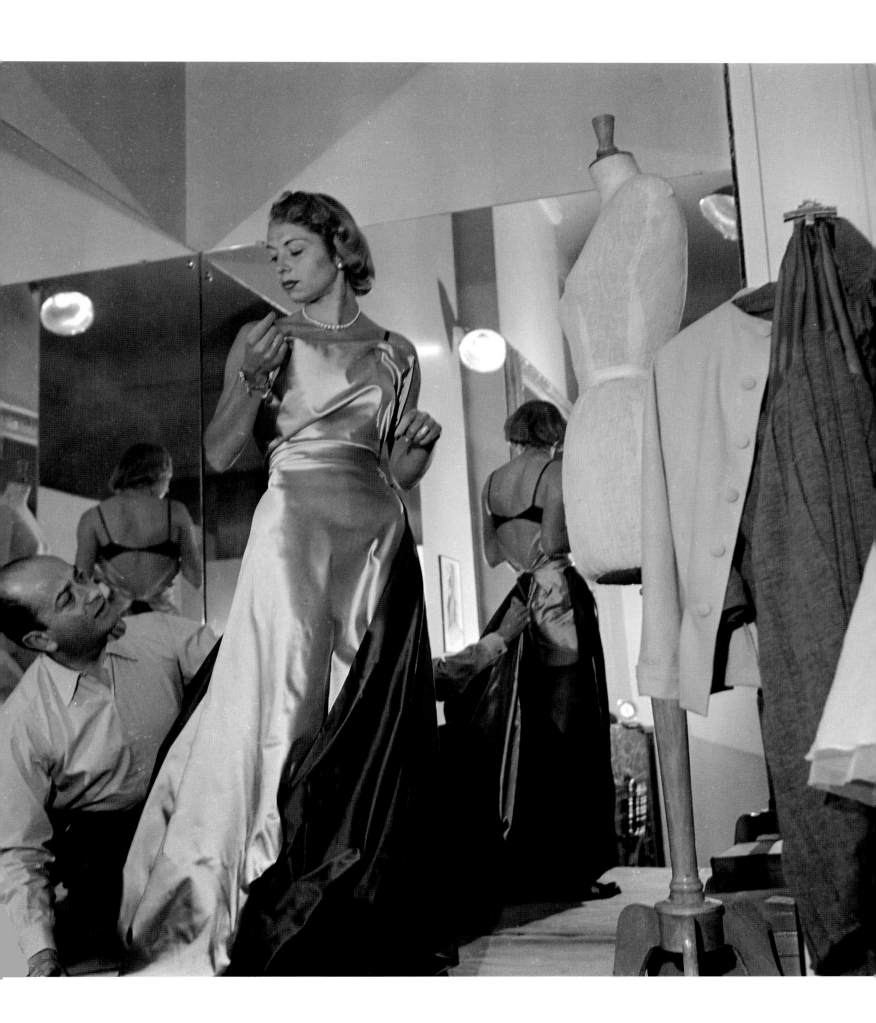

time too late for showing it to another potential client or producing it. Consequently, suppliers were forced to create many designs knowing that a proportion would never be ordered.

Any distinctions between the design of the garments, the creators of the textiles and any embellishments that were used were subsumed under the couture house name. This was a symbiotic arrangement, since the suppliers relied upon orders from the couture houses as much as the couturiers relied upon the suppliers. During the 1950s there were around a dozen embroidery houses in Paris. They purchased the ground for their samples from the textile manufacturers, so in turn were responding to and relying on textile manufacturers' designs and colours. The major embroidery houses of Lesage and Vermont produced 180–300 samples a season, which they showed in December and June. In order to try to appeal to the tastes of as many couturiers as possible and ensure sales, Jean Vermont always bought a variety of textures and weights, such as light gauze, stiff satin, organza, tulle and always velvet for winter. François Lesage remarked that embroidery houses proposed, rather than imposed, their creations.[19]

The number of designs produced by each couture house depended upon the scale of the couture house operation. In order to cover the full range of social occasions and events a client might have to attend, each collection encompassed morning, afternoon and evening designs. The moderate-sized salons of Griffe and Dessès designed around 110–170 garments a season, while Dior presented between 230–250, of which approximately 48 would eventually be eliminated, either because they were acknowledged as unsatisfactory to the couturier or buyer, or because they served only to generate publicity. There were often more Spring/Summer designs than Autumn/Winter, as these were generally less expensive to produce. In sum, it was estimated that the Paris couture houses collectively showed around 6,000 new designs a season during the mid-1950s.[20]

Once designed, the nascent *modèle* was made up in one of two types of workshop – the *tailleur* (tailoring) atelier, or the *flou* (dressmaking) atelier – depending on the hand skills that the materials and shapes required. Seamstresses, called *petites mains*, were specialists in the techniques of tailoring or draping, and by constantly working with particular materials perfected their art (pl.3.7). The design would initially be given to the *première d'atelier* in charge of a workroom, who would decide which seamstress was best suited for the individual design. The *première* was the liaison between the design studio and atelier, and also between the salon and the atelier. Each *première d'atelier* had two assistants: one who gave out the work and another who looked after the supplies of materials.

Seamstresses worked around tables in small groups and each became an integral part of the creation (pl.3.1). They were categorized and paid according to their technical abilities and experience, but all started out as *arpettes* (apprentices), learning finishing skills and observing workroom operations. After two or three years they either left the trade or began

as a second hand, called a *deuxième main débutante*. They would then graduate to the position of *deuxième main*, and finally *deuxième main qualifiée*. Each promotion was based upon an assessment of a piece of work. Some women progressed to the next stage, the *première main*. They then began as a *première main qualifiée*, and could become a *première main deuxième échelon*. After around 10 years, a seamstress could become a *première main hautement qualifiée*. If she worked in the *flou*, only then was she entitled to work on a new *modèle* and had full responsibility, from cutting it out to its final completion. In the *tailleur* atelier, the *seconde* cut and the *tailleur* was responsible for the complex sewing.[21]

All couture house staff, whether apprentices, seamstresses or saleswomen, usually came through referrals from friends or relatives. Paule Boncourre began at the house of

3.7 The *flou* atelier at Christian Dior, *c.*1947. Christian Dior Archive

Christian Dior as a 15-year-old apprentice in October 1947, through an introduction from a relative who was working for another couture establishment. She steadily worked her way up through the echelons of the *flou* during her 40 years' experience. As an *arpette* she developed basic sewing skills by over-casting seams, covering buttons and findings. During her first year she also attended a technical college one day a week, working towards the Certificate of Professional Aptitude (C.A.P.), the accreditation established by the Chambre Syndicale for workroom employment in a couture house. She passed, and worked for one more year as an apprentice hand. She then became a *deuxième main* and 10 years later a *première main hautement qualifiée*. She favoured working with *mousseline*, tulle and georgette, lightweight and slightly stiff fabrics that are difficult to handle because they can shift as you work. She said that in haute couture sewing, 'Everything is in the technique: the reverse must be as beautiful as the face.'[22]

Once the sketch or draped piece had been delivered to a workroom, it was used as the basis for making the *toile*, the design made up in unbleached cotton.[23] The *toile* was marked up in ink and red tape ribbons or threads, so that it could be taken apart and used as the basis for the pattern. It was then fitted to one of the in-house models, who were each measured as carefully as a 'gold bar being put into the Bank of England'. Only when a *toile* was judged to be 'perfection' was it made up in cloth, thus becoming a *modèle*.[24] The pattern pieces were cut from the specified textile by the *première main hautement qualifiée*, who assigned the parts to the appropriate workers. If the dress required embroidery it would be sent out at this stage, either already cut or marked for cutting. François Lesage usually allowed two weeks from the order date for the embroidering of a design.[25]

Fittings on models were part of the development of the designs and were likened to 'what the chrysalis is to the butterfly. Raw material and scissors take charge.'[26] Models

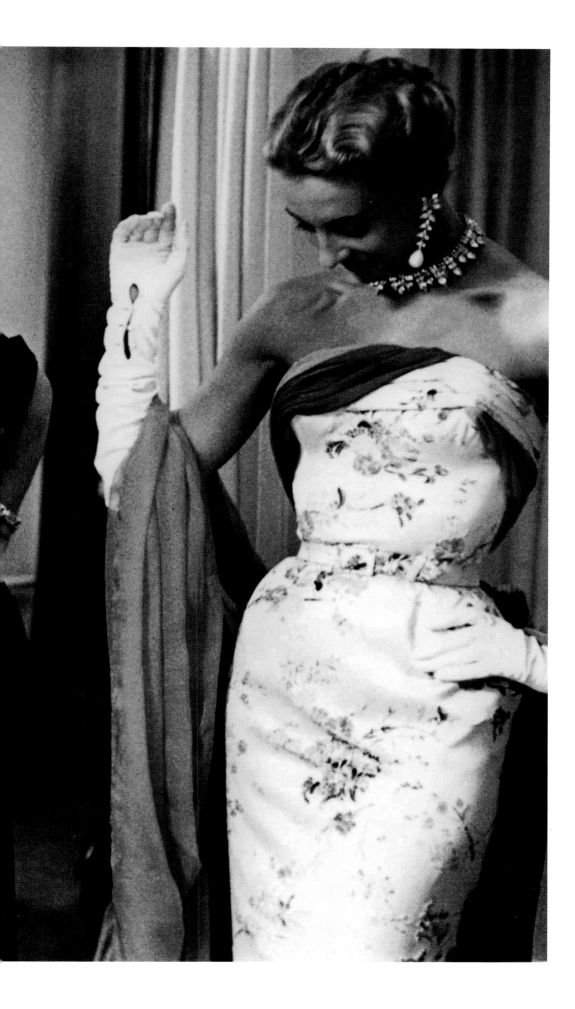

3.11 Ginette Spanier, the *directrice* at Pierre Balmain, shows an evening gown from the Autumn/Winter 1953–4 collection to a commercial buyer and fashion editor, 1953

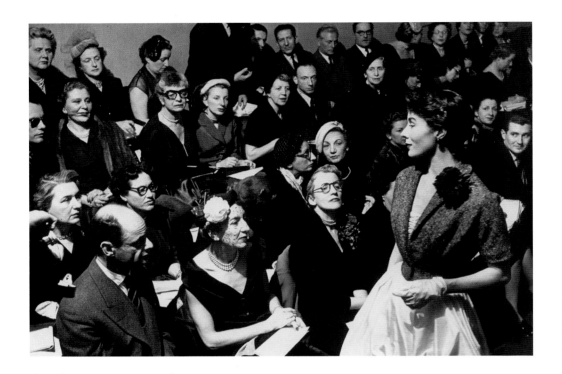

3.12 Shantung dress with tweed jacket modelled by Bettina for the press show of Hubert de Givenchy's first collection, 1952

of 20 he employed in his Paris atelier, François Lesage would hire over 100 women, all working in small ateliers that specialized in beading, embroidery or *passementerie*, in the towns of Lunéville, Nancy, and Baccarat in Lorraine. Jean Vermont employed more of these same workers, and travelled back and forth from Paris to the provinces with his embroideries by car and train. This outsourcing also enabled him to avoid paying benefits and dealing with French employment regulations for small businesses with 50 or more employees (he never hired more than 49 workers for his Paris atelier).[36]

The numbers of Paris haute couture repetitions made in such a short time were indeed impressive and make it clear that an haute couture dress is rarely unique, but rather one of a few. In fact the more fashionable and successful the design the more it was reproduced in the original and subsequent versions. In one year, 1954–5, at the average-sized house of Jacques Griffe, 1,650 repetitions were produced. The smaller house of Jean Dessès produced 1,494, whereas Christian Dior made over 5,000. It was estimated that 'Two out of five [workers] in France are gainfully employed in… needle, textile, or allied trades… that includes… dressmaking and millinery, textile workers, manufacturers of accessories, notions and all types of soft goods.'[37] Thus, although it is difficult to know exactly how many of a particular *modèle* were made, it is clear that Paris haute couture designs were reproduced in their thousands each season.

The commercial orders were exported by land and air to manufacturers, department stores, boutiques and provincial dressmakers around the world, where the latest Paris haute couture designs would be shown in fashion shows, sold, copied and modified, and sketches and photographs of the *modèles* disseminated. Sydney Blauner, buyer for the New York firm Suzy Perette, put it bluntly: 'If you don't come to Paris, you're missing the boat. There are more ideas in a thimble here than in all of America.'[38]

The Domestic Couture Salon and the Private Client

One month after the first showings and delivery of commercial orders, private clients entered the Paris haute couture salons. 'Here indeed was woman's secret world... the battlefield where the struggle against the ravages of age was carried on with the weapons of the dressmaker's art and where fortunes of money were spent in a single afternoon.'[39]

Just as social contacts facilitated an employee's entrance to the couture house, so too did these influences apply to the client. A woman who wanted to buy haute couture at a Paris salon gained entrance by referral. This was often through a friend or relative, who would provide the name of her *vendeuse*, or else the *directrice* of the couture salon would assign a *vendeuse* to a new client. A *vendeuse* would also develop relationships with the concierges of prestigious hotels, who would pass along her name to guests in need of an introduction to a particular house. In this way the haute couture salon was part of the wealthy tourist's Paris experience in the tradition of the Grand Tour.

Reminiscing about the house of Balenciaga, Bettina Ballard, fashion editor of American *Vogue* (1946–54), remarked: 'It is a brave woman who walks in unknown and unheralded to spend her money. There is no place where it is more flattering to be received as an habitué and friend, and there is no place that can seem more impenetrable if one is not known.'[40] Paul Gallico's charming 1957 novel, *Mrs 'Arris Goes to Paris*, tells the story of a working-class English woman whose dream it is to own an haute couture dress. He describes Mrs 'Arris's reaction when she finally entered the house of Dior:

> She was almost driven back by the powerful odor of elegance that assailed her once she was inside. It was the same that she smelled when Lady Dant opened the doors to her wardrobe... it was compounded of perfume and fur and satins, silks and leather, jewelry and face powder. It seemed to rise from the thick gray carpets and hangings, and fill the air of the grand staircase before her. It was the odor of the rich...[41]

Private clients made appointments through their *vendeuse* to see the private fashion show that was held daily from 2.30 to 5pm. The salon was set with lavish floral arrangements and the house perfume would be sprayed in the air. A client would be seated in the salon on an elegant gilt chair, and given a programme so that she could make notes on the pieces that were of interest. After the *passage* the client could request to see the garment again, either on the model or at close hand, by trying it on in a dressing room (pl.3.14).[42]

The job of the *vendeuse* was to guide the client's taste, ensuring that she was perfectly attired. It required a great degree of social skill. Hardy Amies recognized that '[a] good *vendeuse* will know the family history of her client, her lifestyle and the size of her fortune. She will anticipate the customers' requirements.' Once a garment was

ordered, it was the *vendeuse* who was the liaison between the house, the workroom and her client, and who arranged for the three fittings and delivery.[43]

The *vendeuse* Sophie Gins described her career at Christian Dior, which began when she was 19. She was referred by her mother, who was working in the office of Marcel Boussac, the textile manufacturer who had helped Dior establish his house. Her first job was as a telephone operator for the four phone booths available to clients in the salon. Within a few months, Madame Lanciene, one of the 22 *vendeuses*, asked her to become her *seconde*. Her duties included obtaining the requested *modèles* for the client after the shows, and being responsible for the related paperwork that tracked the progress of the garments to and from the atelier and salon for fittings. She later became a full *vendeuse* and worked for the house of Dior for 20 years.[44]

An haute couture *modèle* was only really successful once it had been ordered. It was conceived to be worn outside the couture house, and this was the real measure of its success, aesthetically and financially. Only then was the couturier's skill recognized and confirmed. At this point the design also began to take on a romantic significance for the client that went beyond the material, workmanship, design and expense. It began to symbolize future pleasures to be experienced as an elegant woman wearing the garment. It represented the private haute couture client's entire experience of consumption – from her reception in the salon to seeing the collection, selecting a design, being fitted and finally wearing the haute couture garment that had already required hours of her time. She was completely invested in the purchase. Paul Gallico described this memory for Mrs 'Arris:

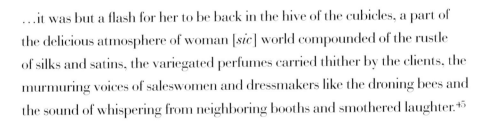

>...it was but a flash for her to be back in the hive of the cubicles, a part of
>the delicious atmosphere of woman [*sic*] world compounded of the rustle
>of silks and satins, the variegated perfumes carried thither by the clients, the
>murmuring voices of saleswomen and dressmakers like the droning bees and
>the sound of whispering from neighboring booths and smothered laughter.[45]

The same garment, even if never again worn, could later also recall wonderful memories of its acquisition and wearing. It was a clear reminder and physical expression of the client's successful assertion of her own personal taste and identity. Although Mrs 'Arris's recollection was fiction, the real and complex experience of purchasing a Paris haute couture *modèle* was conveyed in a thank-you note to the house of Pierre Balmain, from a private client upon receipt of her new dress:

>It gave me a taste for life again. Never mind the dress: its sheer arrival was
>enough, carried by a man in uniform, in its enormous new cardboard box,
>surrounded by pounds of tissue paper. When I signed for it I felt everything
>was worth while, that life was exciting again. Thank you ...[46]

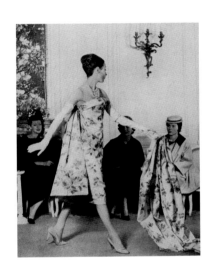

3.14 Private clients watch the *passage* at Christian Dior. *Harper's Bazaar* (American edition), March 1956. Photograph by Louise Dahl-Wolfe

3.13 'Batignolles', day suit by Christian Dior. Worsted, Spring/Summer 1952. Worn by Mrs Opal Holt and given by Mrs D.M. Haynes and Mrs M. Clark, V&A: T.110–1982

Jean Dessès

SONNET STANFILL

Jean Dessès opened his Parisian atelier in 1937, two years before France went to war. In a report published in French *Vogue* on the state of fashion as war began, Dessès announced that his atelier 'still remains open, creating designs in harmony with real life'.[1] In 1946 Dessès moved to the Champs-Elysées, into the stately mansion previously owned by architect Alexandre Eiffel. In this post-war period, when restrictions on materials and shifting client fortunes might have threatened his young business, Dessès found great success. He designed the wedding outfits for Princess Sophia of Greece to Prince Juan Carlos, and his many clients included the Hon. Mrs J. J. Astor and Viscountess Waverly, both of whom donated dresses to the V&A. The luxurious textiles and skilled construction techniques seen in these gowns suggest the high level of quality and workmanship that French couture houses managed to maintain during the period of France's recovery.

Dessès's career-long preoccupation with draping and form resulted in gowns defined by their femininity, technical complexity and use of sheer fabrics that required skilful handling. Although he was born in Alexandria, Egypt, in 1904, his ancestry was Greek, and his signature pieces – columnar, draped and pleated evening gowns created in silk chiffon – alluded to classical antiquity. In his early designs, Dessès's evening wear is characterized by a subtle colour palette of creams, beiges and pale pinks, but later he introduced vibrant reds, often employing two similar shades in the same dress but softening their intensity by using matt chiffon fabric. A strapless red evening dress from around 1953 highlights Dessès's virtuoso pleating. The skirt's delicate drapery envelopes the wearer in softly gathered swags, and a long tie crosses over at the neck, falling to the back. The intricate pleating across the bodice is an example of a construction technique Dessès favoured for both early evening and formal occasions. Although the bodice appears to be soft and unstructured, it features the sewn-in boning common at the time.

Further evidence of Dessès's precise pleating can be seen in a 1951 cocktail dress. The bodice's composition of curving pleats with a pattern suggestive of waves fits closely to the body; the dress then tapers to a narrow waist, and swells into a full skirt of soft pleats. Referencing the colouring of a sailor's uniform, Dessès chose royal blue for the dress and white cotton piqué to trim the collar and cuffs of the silk chiffon over-jacket (not illustrated).

A dusty brown cocktail dress from around 1955 illustrates Dessès's artful construction. The cobweb-like skirt is crafted from 21 lace-trimmed squares, each suspended from a point at the waist and falling to a handkerchief hem. By stitching each square to the next in a carefully plotted pattern, Dessès created a skirt of graceful volume and movement. The criss-cross placement of lace on the bodice draws attention to the *décolletage* of this otherwise demure dress.

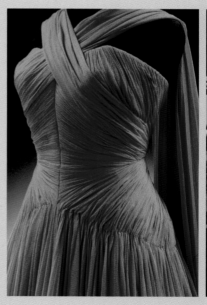

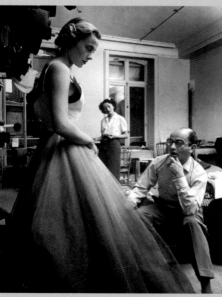

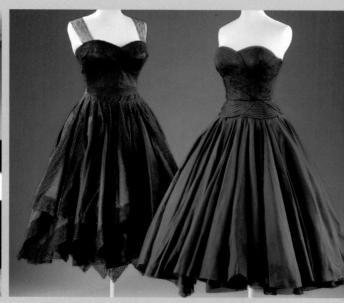

3.15 Evening dress by Dessès. Chiffon, c.1953. Worn by Mrs Opal Holt and given by Mrs D.M. Haynes and Mrs M. Clark, V&A: T.105–1982

3.16 Jean Dessès with model Christiane Richard, 1950. Photograph by Nat Farbman

3.17 Cocktail dresses by Jean Dessès. Left: silk and lace 'handkerchief' dress, 1954–5. V&A: T.34–1988. Right: silk pleated dress, 1951. Given by Princess Margaret, V&A: T.237–1986

3.18 Dress by Jean Dessès. Chiffon, 1953. Photograph by Seeberger

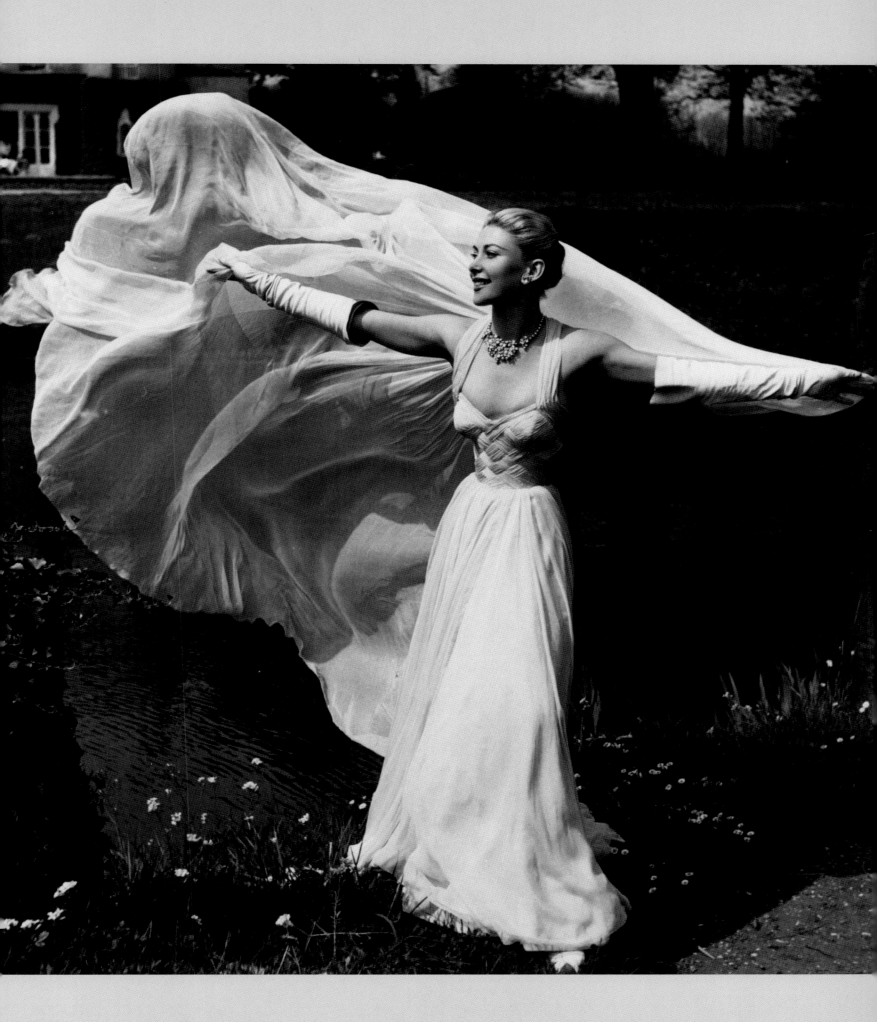

Jacques Fath

ELERI LYNN

Jacques Fath was born in 1912, just outside Paris. Self-taught, he had a flair for youthful, headline-grabbing designs, and a skill for what would become increasingly important to the world of fashion – publicity. Fath had tremendous personal appeal and he promoted his own image with care. In his opinion Balenciaga was too severe and, although he admired Dior, he was known to tease him about his 'bourgeois sérieux' manner. Unlike his fellow couturiers, Fath was held up as a model of style: articles appeared in men's magazines describing how to emulate his 'masculine elegance', along with photographs of the couturier showing off his matinée-idol looks or smiling engagingly at the camera. His was a delightful dandyism that made him a darling of the press and his clients (whom he would address individually as 'mon poulet'). Celia Bertin wrote of first meeting him: 'He had a showy elegance, this splendid young man with the charm of an "enfant terrible"... I couldn't take my eyes off him the whole evening.'[1]

Fath would often appear in the company of his wife, Geneviève, who was his business partner, model and best advertisement. She dressed immaculately in his designs, and always captured press attention. For a promotional tour to the United States in 1948, Mme Fath's $12,000 wardrobe consisted of 35 outfits and dozens of accessories, which filled 12 large trunks.[2] The trip was a runaway success, quadrupling sales at the Paris salon. Describing her as Fath's 'walking show window', *Life* magazine commented: 'At receptions in seven US cities both Mme Fath and her clothes have been enthusiastically received. So, also, was her husband's comment that many American women do not show off their figures enough.'[3]

Fath invested in the creation of a glamorous world. Even in the years directly after the war it was rumoured that he would spend $3,000 a year on champagne for his collection launches, which were described as a mixture of a Hollywood première and an opening night at the opera. He regularly attended celebrity events such as the Cannes film festival, and threw dinner parties at his villa in the Midi, or dined at restaurants, his presence attracting huge crowds. The greatest events of the calendar were, however, Fath's own celebrity-studded parties, lavish themed balls for clients, buyers, press and friends at his chateau at Corbeville. The photographer André Ostier, one of Fath's friends, recalled how 'all Paris dreamed' of being invited.[4] Fath's self-promotion and publicity campaigns were hugely successful, but at their core were chic and feminine designs, a thriving ready-to-wear business with the American firm of Halpert, and a devoted clientele. The dissemination of the Fath look and lifestyle resulted in haute couture sales that were second only to Dior's at the time of his death in 1954. His very public and apparently boundless *joie de vivre* made his early death seem all the more tragic. Celia Bertin found the idea unthinkable: she preferred to imagine 'that he was working incessantly, that he was travelling – that he had been to a party'.[5]

3.19 Jacques Fath as the Sun King with his wife, Geneviève. Venice, 1951

3.20 Jacques Fath, 1950

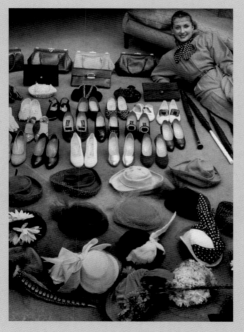

3.21 Geneviève Fath with her accessories for an American tour, April 1948

3.22 Jacques Fath with a model and a client, 1951

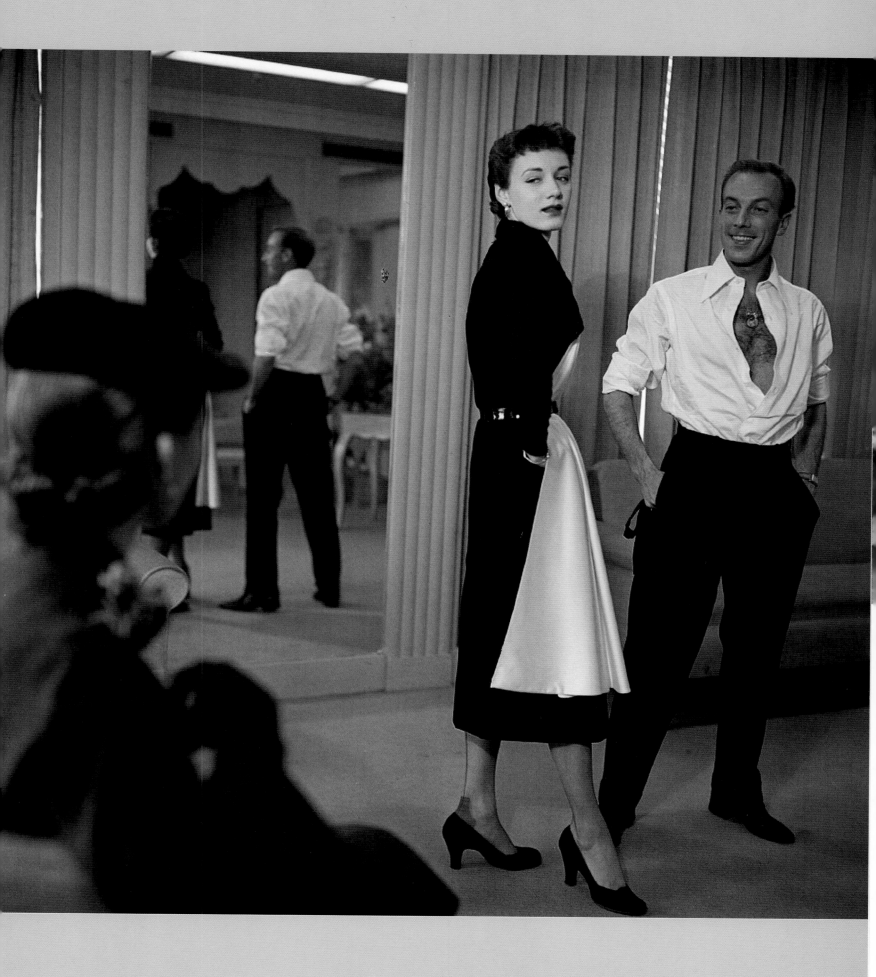

of special occasions – the intrinsic value of clothing is rarely financial) to be offered to the Museum for posterity. The couture client often possesses an extensive wardrobe of little-worn clothing, which explains why these garments – especially the tailored clothes, which would normally endure most use – are in good condition, although some have been altered during the period of their wear. The V&A's collection of couture tailoring from this time includes garments by Digby Morton, Hardy Amies, Norman Hartnell, Lachasse, Charles Creed and Michael Sherard.

Digby Morton trained as an architect before taking up a career in fashion. In 1928 he was appointed designer for the newly opened House of Lachasse. Hardy Amies, his successor at Lachasse, observed:

> Morton's philosophy was to transform the suit from the strict *tailleur*, or the ordinary country tweed suit with its straight up and down lines, uncompromising and fit only for the moors, into an intricately cut and carefully designed garment that was so fashionable that it could be worn with confidence at the Ritz.[12]

Morton continued to specialize in tailoring in his own salon. Quite typical of his designs is an ensemble made from green, beige and brown checked worsted which dates from 1947–8, and was worn and given to the V&A by Mrs Benita Armstrong (pl.4.5). The styling and colours were highly fashionable and entirely characteristic of Morton's preference for muted tones. The jacket was made by Morton's tailor, Roger Brinès, whilst the pleating of the matching dress involved the skills of an external workshop. A specialist company such as Ciment or Gilbert would have pleated the quarter circles of sun-ray pleats on the skirt (an expensive process which cost about £12),[13] and the fine green leather belt, which matches the dress perfectly, would have been ordered from an exclusive leather company such as Madame Crystal. What is perhaps unusual about this ensemble is the absence of distinctive pockets – Morton adored pockets, and he used them imaginatively and profusely.

Another suit by Digby Morton, named 'Chesterfield' after the velvet-collared coats worn by the trend-setting Earl of Chesterfield in the 1830s and 1840s, features cuffed pockets which emphasize the curve of the hips (pl.4.4). Dating from 1954, when black-and-white checks were the height of fashion, this lean-cut, shapely suit is accessorized with a small, fringed, bow-shaped scarf in matching tweed, which is lined with black silk velvet. Morton advised the client – Mrs Opal Holt – that, teamed with a discreetly checked blouse, this ensemble was ideal to wear at the races.

Hardy Amies was an astute businessman as well as a talented designer. In his autobiography *Just So Far* (1954) he describes his early career at Lachasse and Worth and explains how he developed his own couture business at home and abroad. To keep his business afloat Amies needed to sell 2,000 garments a year.[14] His clients generally

'Morton's philosophy was to transform the suit... into an intricately cut and carefully designed garment that was so fashionable that it could be worn with confidence at the Ritz.'

HARDY AMIES

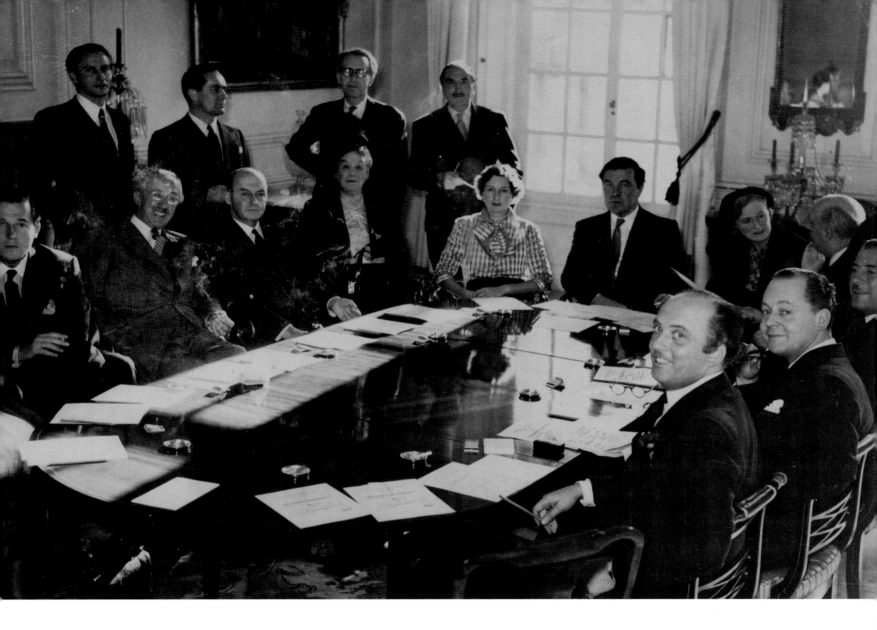

4.2 The members of INCSOC, October 1949. Standing, from left to right: Michael Sherard, Giuseppe Mattli, Victor Stiebel and Peter Russell. Seated, from left to right: Hardy Amies, William Haigh (National Wool Textile Export Corp.), Colonel Crawford (Bianca Mosca), Mrs C. Mortimer (Worth), Viscountess Rothermere, Norman Hartnell (Chairman), Miss Lilian Hyder (Organizing Secretary), Sir Raymond Street (Cotton Board), R. A.G. Barnes (Lace Federation), Digby Morton and Charles Creed. V&A Archives

London but subsequently moved to New York. From the mid-1940s, London's couture industry expanded: Angèle Delanghe opened in 1944, Hardy Amies, Charles Creed, Michael Sherard and Bianca Mosca each opened a house in 1946, Ronald Paterson in 1947, John Cavanagh in 1952 and Michael Donéllan in 1953. London's couture industry was centred on Mayfair.

The early years following the Second World War proved challenging for London's couturiers. Rationing continued until 1949, the Utility Clothing Scheme remained in force until 1952, and, whilst luxurious fabrics were available for export, they were in short supply for the home market. Taxes introduced by the new Labour government adversely affected the couturiers' home clientele, and the devaluation of the franc in 1948 rendered London a relatively expensive market abroad. Nonetheless, export sales – critical for the commercial survival of many houses – remained high. In 1950 the Annual Report of the Incorporated Society of London Fashion Designers (INCSOC) declared that 'The main aim of the Society is to promote the London Fashion Designers and British fabrics at home and overseas. Because of present-day conditions the Society's activities are confined almost exclusively to developing the dollar market overseas [pl.4.2].'[2]

Some insight into the internal workings of a London couture house can be obtained

from publications of the day. In 1946 *The Strand* magazine documented that the staffing of an 'average' house included two *vendeuses*, who earned about £6 (equivalent to about £162 in 2006) a week plus commission. As in Paris, London's couture workrooms were divided between tailoring and dressmaking. Each workroom was headed by a tailor or dress fitter: women in this position earned between £10 and £20 and the men a few pounds more. *Secondes*, who earned about £2 a week, distributed work to 'the hands' who in turn passed work on to juniors. These girls, of whom there were between 40 and 60, earned £2–4 a week. Whilst some houses had full-time models, *The Strand* stated that on average there were two models, who earned £3–5, provided their own shoes and cosmetics, and were often laid off at slack times.[3]

With the exception of Hartnell, who had his own embroidery workrooms, couturiers sent their cut work to a specialist company such as Paris House (in London) to be embroidered (see Chapter 5 and p.136). The couturiers also made use of specialist pleating houses, furriers and glove-, belt-, bag-, shoe-, button- and artificial flower-makers. Ann Scory was London's leading maker of artificial flowers, created in silk, chiffon, velvet and feathers, for the couture houses, and also made flowers for the Queen. To complete their ensembles they regularly commissioned creative milliners, including John Reed Crawford, Eric, Otto Lucas, Simone Mirman, Rudolf, Aage Thaarup and Madame Vernier, whose trade union organization was the Associated Millinery Designers of London. From 1956 these craftspeople and companies could apply for Associate Membership of INCSOC.

Unlike their Paris colleagues, throughout this period London's couturiers received little support from the state or backing from fabric manufacturers. However, building upon relationships forged during the Second World War, INCSOC worked collaboratively with textile organizations such as the International Wool Secretariat (IWS) and the Cotton Board to publicize the couturiers' work. Some London couturiers secured modest licensing contracts, but did not enjoy the lucrative deals offered to top Paris designers. Nor did they earn major revenue from perfume sales. Their wage bills were also higher. An article appearing in *The Economist* in 1951 compared the couture industries of the two cities, stating that 'Paris, with its tradition of *couture*, is rich in trained and experienced people; in London they have a scarcity value. The London house, moreover, has to pay purchase tax at the rate of 22 per cent on each quarter's sales.'[4] It is perhaps surprising, therefore, that London couture in 1951 was competitively priced: a Parisian dress might cost £300 (equivalent to £6,525 in 2006) whilst a comparable London model cost about half this amount at £152.10s., including tax for the home market.[5]

In 1952, leading London couturiers Norman Hartnell and Hardy Amies employed 400[6] and 200[7] workers respectively, whilst Michael Sherard operated with a small team of just 40.[8] By contrast, a leading Paris house employed between 500 and 850 workers and showed some 150 designs in January and July, as well as offering mid-season collections.[9] Amies' collections were less than half this size: he showed 60 ensembles, of

which 20 were day dresses (some with coats or jackets), 20 suits (some shown with overcoats) and 20 evening dresses (including cocktail and party dresses).[10] Amies stressed: '[E]very model in my collection has to do a job, the job of taking orders. Only rarely can I allow myself the extravagance of making one to do the job of making publicity.'[11]

London's couturiers necessarily created small collections of eminently wearable clothing for the social elite. This was made explicit by the fashion editors at *Vogue* and *Harper's Bazaar*, who presented the London collections in contexts specific to a particular occasion, identifying stylish and appropriate garments for the Royal Garden Party, Goodwood, Wimbledon, Ascot, Cowes, coming-out dances and summer balls, which were followed by winter months in the country (pl.4.3). This was given further endorsement through features picturing couture clients and their debutante daughters in their magnificent houses and grounds. London's most high-profile couture clients were the British royal family, and the 1953 Coronation provided an international showcase for the couturiers' designs (see p.110).

Tailoring

Most of the couture garments described here were ordered by the client, made to fit perfectly and worn for social events. They were subsequently carefully packed away and some sufficiently valued (in terms of provenance, design and perhaps as mementoes

4.3 'Days in Town', tailored suits by (from left to right) Hardy Amies, Michael Donéllan and Charles Creed, with hats by Vernier and Rudolf. *Vogue* (British edition), September 1953. Illustration by René Bouché

of special occasions – the intrinsic value of clothing is rarely financial) to be offered to the Museum for posterity. The couture client often possesses an extensive wardrobe of little-worn clothing, which explains why these garments – especially the tailored clothes, which would normally endure most use – are in good condition, although some have been altered during the period of their wear. The V&A's collection of couture tailoring from this time includes garments by Digby Morton, Hardy Amies, Norman Hartnell, Lachasse, Charles Creed and Michael Sherard.

Digby Morton trained as an architect before taking up a career in fashion. In 1928 he was appointed designer for the newly opened House of Lachasse. Hardy Amies, his successor at Lachasse, observed:

> Morton's philosophy was to transform the suit from the strict *tailleur*, or the ordinary country tweed suit with its straight up and down lines, uncompromising and fit only for the moors, into an intricately cut and carefully designed garment that was so fashionable that it could be worn with confidence at the Ritz.[12]

Morton continued to specialize in tailoring in his own salon. Quite typical of his designs is an ensemble made from green, beige and brown checked worsted which dates from 1947–8, and was worn and given to the V&A by Mrs Benita Armstrong (pl.4.5). The styling and colours were highly fashionable and entirely characteristic of Morton's preference for muted tones. The jacket was made by Morton's tailor, Roger Brinès, whilst the pleating of the matching dress involved the skills of an external workshop. A specialist company such as Ciment or Gilbert would have pleated the quarter circles of sun-ray pleats on the skirt (an expensive process which cost about £12),[13] and the fine green leather belt, which matches the dress perfectly, would have been ordered from an exclusive leather company such as Madame Crystal. What is perhaps unusual about this ensemble is the absence of distinctive pockets – Morton adored pockets, and he used them imaginatively and profusely.

Another suit by Digby Morton, named 'Chesterfield' after the velvet-collared coats worn by the trend-setting Earl of Chesterfield in the 1830s and 1840s, features cuffed pockets which emphasize the curve of the hips (pl.4.4). Dating from 1954, when black-and-white checks were the height of fashion, this lean-cut, shapely suit is accessorized with a small, fringed, bow-shaped scarf in matching tweed, which is lined with black silk velvet. Morton advised the client – Mrs Opal Holt – that, teamed with a discreetly checked blouse, this ensemble was ideal to wear at the races.

Hardy Amies was an astute businessman as well as a talented designer. In his autobiography *Just So Far* (1954) he describes his early career at Lachasse and Worth and explains how he developed his own couture business at home and abroad. To keep his business afloat Amies needed to sell 2,000 garments a year.[14] His clients generally

'Morton's philosophy was to transform the suit... into an intricately cut and carefully designed garment that was so fashionable that it could be worn with confidence at the Ritz.'

HARDY AMIES

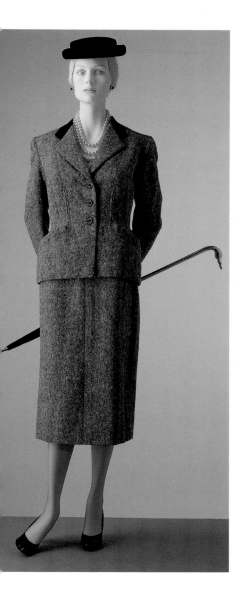

4.4 'Chesterfield', suit by Digby Morton. Wool tweed, 1954. Worn by Mrs Opal Holt and given by Mrs D.M. Haynes and Mrs M. Clark, V&A: T.101–1982

4.5 Suit by Digby Morton. Tweed with velvet trim, 1947–8. Given by Mrs Benita Armstrong, V&A: T.37–1966

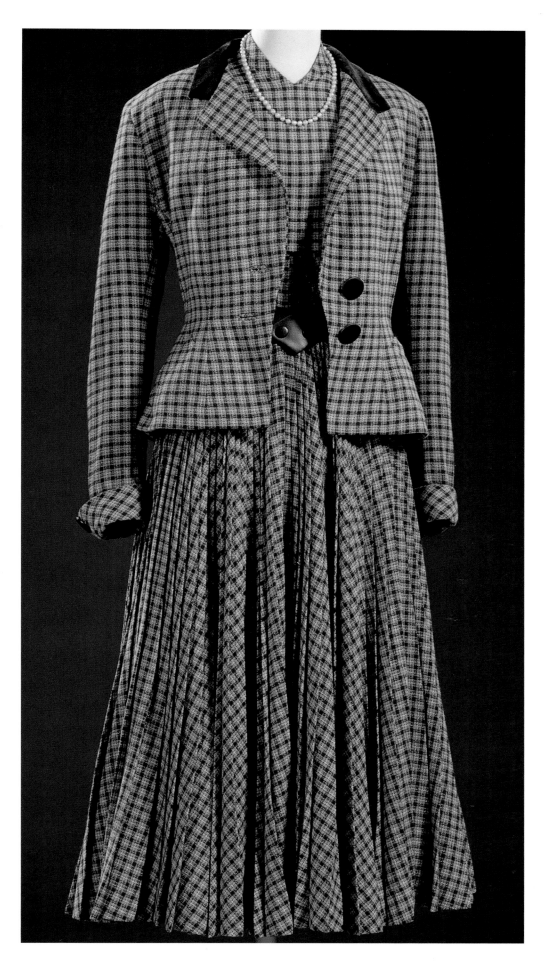

ordered one or two dresses or suits each season, together with '...a series of little ready-made dresses bought extremely cheaply, often under a branded name'.[15] In order to compete in this expanding market, some couturiers – including Amies – opened boutiques, where they sold ready-made clothes or simplified designs that required just one fitting (rather than the usual two or three for a couture garment), along with cashmere knitwear and exclusive accessories.

By 1947 Norman Hartnell had a thriving business dressing society ladies, actresses and – very importantly – British royalty, whose patronage greatly increased his clientele and business. Although he was best known for his romantic evening dresses (pl.4.13), Hartnell was also capable of stylish restraint. A fine black wool coat with asymmetric buttoning and a sloping waistline was ordered by Lady Cassel in 1948 and subsequently donated to the Museum.[16]

Mr Owen – known as 'Owen at Lachasse' – was designer at Lachasse from 1953, when Michael Donéllan left to open his own house. Owen designed a claret-red wool suit chosen by Mrs Dent.[17] The jacket has distinctive wedge-shaped double pocket flaps and the skirt, knife-pleated in the back, was shortened during the course of its wear. The suit was worn with a red and black jersey hat from Lachasse and an embroidered and fagotted blue-grey crêpe-de-chine blouse labelled 'Givans'. The V&A originally dated this suit to around 1949 but research in the sales ledgers of the Lachasse archive reveals that it was in fact purchased in May 1954. (Stylistically it could have been designed at either time.) These fascinating ledgers document the purchasing patterns of Lachasse's clientele and reveal the prices they paid. The suit cost £58.6s (about £1,200 by 2006 prices) and the hat £10.10s (about £200). The ledgers show that Mrs Dent and her daughter placed regular orders for coats, suits, dresses and hats, and also had several alterations undertaken between 1938 and 1955.

Before working in his family couture house, Creed, in Paris (established 1870), Charles Creed was taught practical tailoring skills in Vienna and learned about the properties of fabric at Linton Tweeds; he gained commercial experience working in New York's fashion retail and wholesale industries. During the war Creed designed for the exclusive London store Fortnum & Mason, and shortly afterwards opened his own salon at 31 Basil Street, taking two fitters from Fortnum's with him (such staffing moves were common in the industry and clients would follow a valued designer or fitter). Creed specialized in tailoring: when he did make evening dresses they were usually slim and tailored. His unusually masculine Knightsbridge premises had dark panelled walls upon which he hung cavalry hats, and the salon displayed his collection of colourful miniature Napoleonic soldiers. Creed's passion for military uniform was translated into his couture collections: garments trimmed with frogging, braiding and piping, capes, tricorn hats (Simone Mirman and Renée Pavy regularly made hats for Creed) and fobs in place of buttons became Creed signatures. After closing his house in 1966 Creed gave the V&A some model garments, including a mustard-coloured wool suit with decorative black

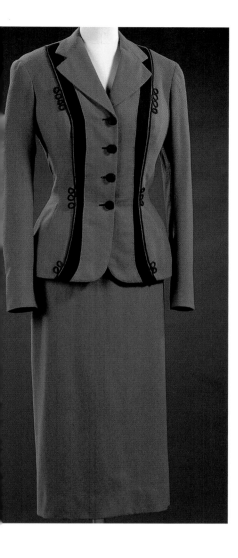

4.6 'Toffee', suit by Charles Creed.
Wool with silk braid, 1953.
Given by Mr Charles Creed,
V&A: T.63–1966

4.7 Suit by Michael Donéllan.
Worsted, 1954. Given by Mrs
Vivienne Cohen, V&A: T.52–1997

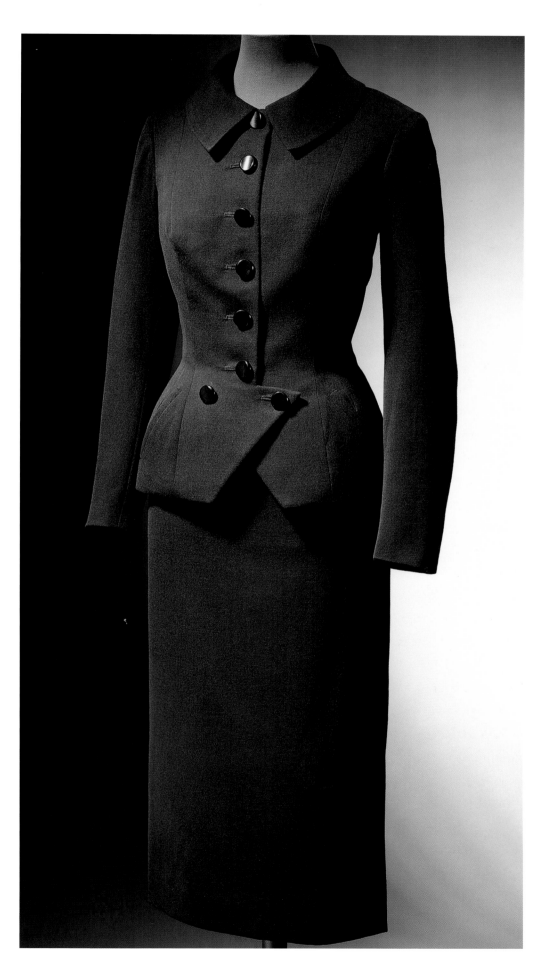

braiding from 1953, which retains the original tape, bearing the model number 1523 and the name 'Toffee' (pl.4.6). The suits epitomize the elegant, elongated lines for which Creed was known, and presumably he decided they would well represent his work to future generations.

Giuseppe Gustavo (Jo) Mattli was best known for his fluid, draped dresses and soft, feminine tailoring. Mattli studied tailoring in London and worked with Premet in Paris before establishing his London house. In 1955 his house went into liquidation and he subsequently moved to Basil Street to share Creed's premises.

In 1937, at the age of 18, Ronald Paterson won first prize for a tailoring design and second prize for a dress design when he entered a competition judged by the innovative Parisian couturier Elsa Schiaparelli. Much encouraged, he developed his skills at the Piccadilly Institute of Design and then worked in Paris. In 1947 Paterson opened a house in Albemarle Street. London's youngest couturier, he stated that he never looked to the past for inspiration;[18] his 1955 'flying saucer hats' (Rudolf regularly made his millinery) were uncompromisingly modern. The V&A has a Paterson suit from the late 1950s made in a heavy beige and brown checked wool.[19] The fashionable boxy jacket has a deep collar which can be worn in a variety of ways. Paterson regularly used checked and textural tweeds and was known for his light handling of bulky materials. The suit, along with a bold yellow precision-cut wool coat also by Paterson, was worn by Mrs C. Nattey and given to the V&A by her mother.

Michael Donéllan, another talented designer who started his career at Lachasse, opened 'Michael', his Carlos Place house in 1953. In spring 1954 Londoner Dr Vivienne Cohen ordered a black worsted suit from him (pl.4.7). The jacket has an unusual Peter Pan collar and curved pockets, and is softly moulded to accentuate the hips. Particularly distinctive is the buttoning, which becomes double-breasted just below the waist.

Victor Stiebel trained with the court dressmaker Reville before opening his own salon at 21 Bruton Street. From the outset, Stiebel aligned himself with the vogue for historical revival styles, and he used striped fabrics imaginatively. During the war, Stiebel's business was run by the Jacqmar organization. He subsequently became Jacqmar's Director of Couture (the label was 'Victor Stiebel at Jacqmar') and the house was located at 16 Grosvenor Street. In 1958 Stiebel became independent of Jacqmar and opened his own house in Cavendish Square.

Evening and wedding dress

As evening dresses and wedding gowns often are our most 'special' clothes, generally worn just once or twice for important occasions and rites of passage, these are the garments that are generally presented to the Museum. From this period, the V&A's collection includes couture evening dresses by Victor Stiebel, Hardy Amies, Norman Hartnell, Worth, John Cavanagh and Digby Morton.

For his Autumn/Winter 1947–8 collection, Victor Stiebel designed a yellow-green

4.8 Evening dress by Victor Stiebel at Jacqmar. Embroidered silk satin, 1950s. V&A: T.172–1969

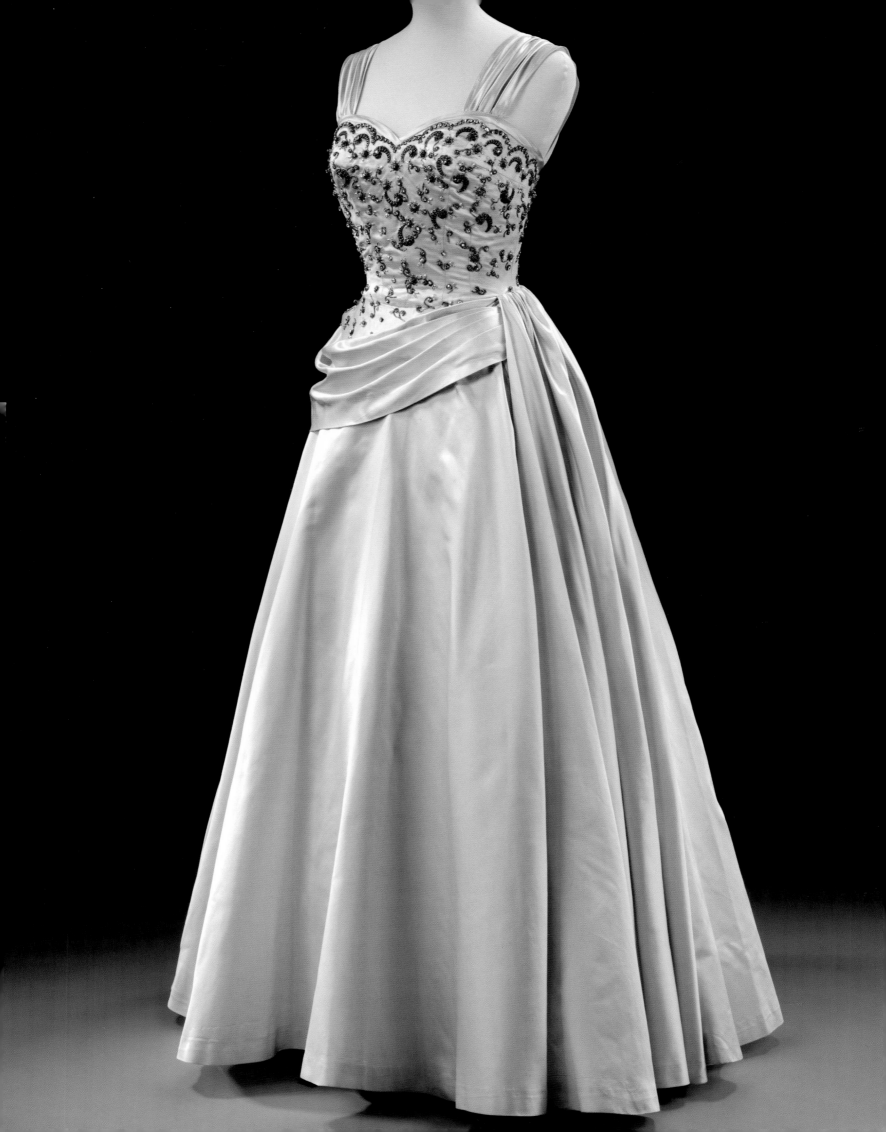

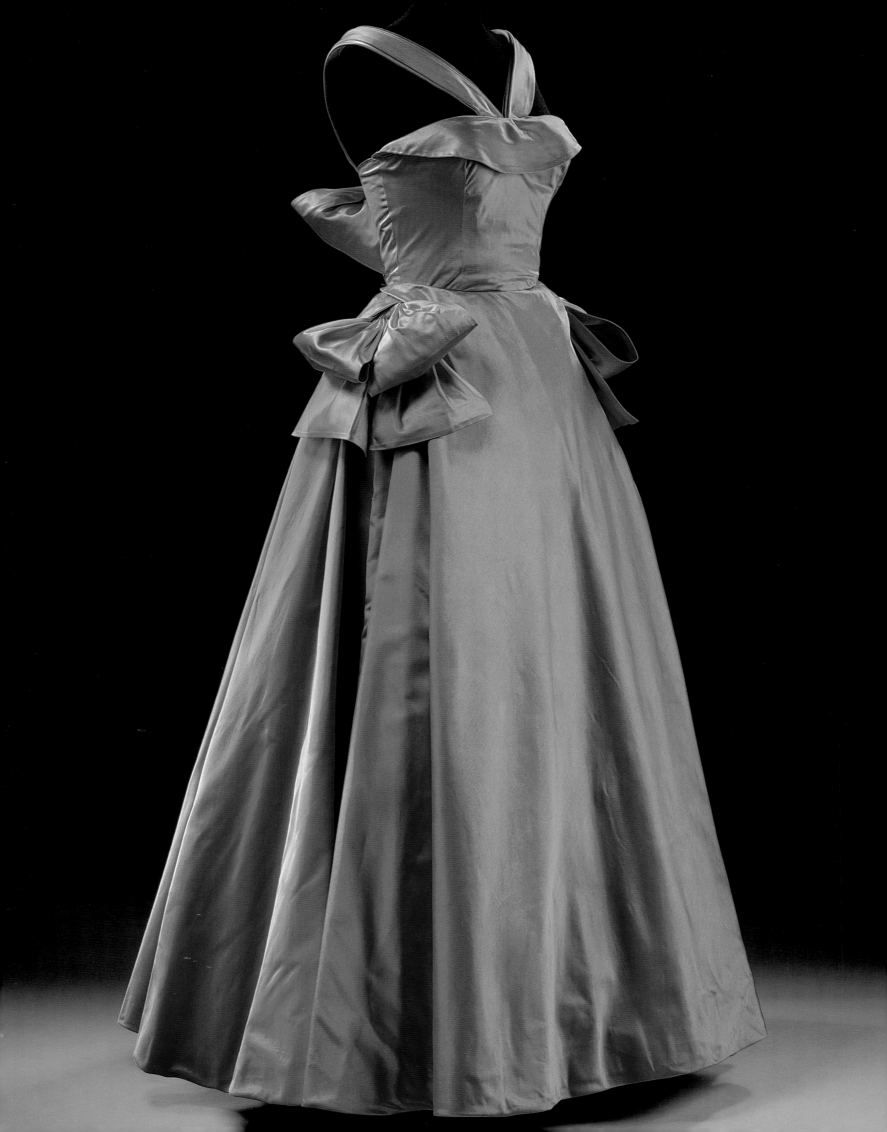

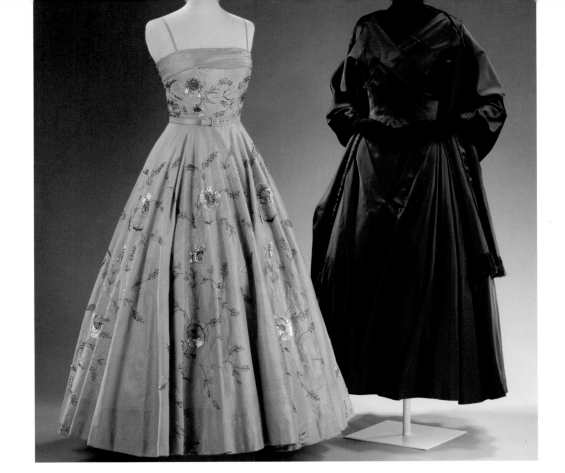

4.9 Evening dress by Hardy Amies. Satin, c.1950. V&A: T.86–2001

4.10 Evening dresses by Worth (London). Left: embroidered wild silk dress, 1955. Given by Mrs Roy Hudson, V&A: T.214–1973. Right: silk dress and stole, 1950s. V&A: T.18–2006

striped late-afternoon dress in silk grosgrain with a distinctive bustle bow which was worn and given to the V&A by Lady Cornwallis. It was a stylish and ingenious interpretation of the New Look.[20] When fabric was no longer scarce, Lady Templer purchased a cream silk satin evening gown, decorated with pearlized beads, rhinestones and silver beads, directly from a Stiebel show; since her shoulders were narrow, his studio added the straps (pl.4.8). The Hardy Amies evening gown that Mrs Lister Bolton chose, executed in crimson silk satin without embellishment, makes an altogether bolder statement (pl.4.9).

In the early 1900s the Paris couture house Worth opened a London branch, which merged with Reville in 1936. Clients were offered designs by Elspeth Champcommunal, a former Parisian designer and editor of British *Vogue*, alongside Parisian ones. In 1953 Owen Hyde-Clark, who had worked with Maggy Rouff in Paris and Bradley's in London, was engaged to design Worth's boutique range. About the same time the Parisian couture house Paquin bought Worth and in 1954 sold the name to Sydney Massin, who launched Worth (London) Ltd. One client, Mrs Roy Hudson, was a friend of Miss Whistler, Worth's head *vendeuse*. She purchased Worth's gowns between 1947 and 1962. Dating from *c*.1955, when Hyde-Clark was also responsible for couture, are two pink silk evening dresses worn by Mrs Hudson, one long and the other in the fashionable shorter length that was acceptable for all but the most formal occasions. Worth was known for delicately embroidered dresses in shades of champagne and rose, and these dresses are typical of the house's output (pl.4.10). However, the V&A also recently acquired a plain navy satin evening dress with matching stole. Worth (London) Ltd closed in 1967.

Bianca Mosca, one of London's two women couturiers, designed accessories for Schiaparelli and managed Schiaparelli's Paris boutique before moving to Paquin's London branch. When Paquin closed during the war, Mosca accepted a position at Jacqmar to design under her own name using their fabric. In 1946 she opened her own house at 22 South Audley Street. The June 1949 issue of *Vogue* observed that Mosca was the perfect model for her own designs (pl.4.11). The magazine published three portraits of her taken by Cecil Beaton, in which she wore a satin house coat with a printed design of pink and black wings, a rust and purple striped tweed suit and a pale grey brocade evening gown woven with tiny butterflies. Bianca Mosca died in 1950, just two months after she had seen the scheme she originated – for a group of five top level British fabrics manufacturers, including Sekers, to form the Associated Haute Couture Fabrics Company – open their Paris office (see p.119).

London's other woman couturier was Angèle Delanghe. In 1948 she presented formal silk gowns with panniers and pretty cotton evening dresses patterned with birds and leaves. By 1950 Delanghe had closed her house at 12 Beauchamp Place, but she reopened at 13 Bruton Street some eight years later.

Peter Russell told author and INCSOC secretary Lilian Hyder that he learned to draw by tracing models from *Vogue* magazine.[21] During the 1930s Russell contributed to the neo-classical revival, presenting evening dresses with accordion and fan-tail pleating, the latter of which he applied to his tailored jackets for his Summer 1950 collection. He was also known for his magnificent formal evening gowns: for the same collection, he presented an oyster-coloured silk satin gown that swept to the floor in unpressed pleats, with a tiny bodice held by a halter neck, embroidered by Paris House. Russell closed his salon at 2 Carlos Place in 1954 (see pl.1.6).

When Michael Sherard, who originally trained as a painter, realized that fashion was his vocation, he approached couturier Peter Russell to undertake an apprenticeship (making Russell the first London couturier to take on an articled pupil, for a premium of £100).[22] In 1946 Sherard opened his house at 24 Connaught Street, where his first collection, shown in February 1947, included evening dresses in cotton and more formal designs in silk, many decorated with a beautiful floral corsage, some of which appeared to be dappled with dew. Sherard worked extensively with lace; the V&A has a black Swiss lace evening dress with raised, self-fabric flowers, designed by Sherard in 1957 for his acclaimed Spring 1958 collection (pl.4.12). The couturier presented this dress to Cecil Beaton for the exhibition 'Fashion: An Anthology' (1971) at the V&A. Sherard closed his salon in 1964.

Norman Hartnell's salon and workshops were located in an eighteenth-century house at 26 Bruton Street, which he had adapted by architect Gerald Lacoste. The

4.11 Bianca Mosca wearing a dress of her own design. *Vogue* (British edition), June 1949. Photograph by Cecil Beaton

4.12 Cocktail dress by Michael Sherard. Lace with appliqué lace flowers, Spring 1958. Given by Mr John Fraser and Mr Michael Sherard, V&A: T.403–1974

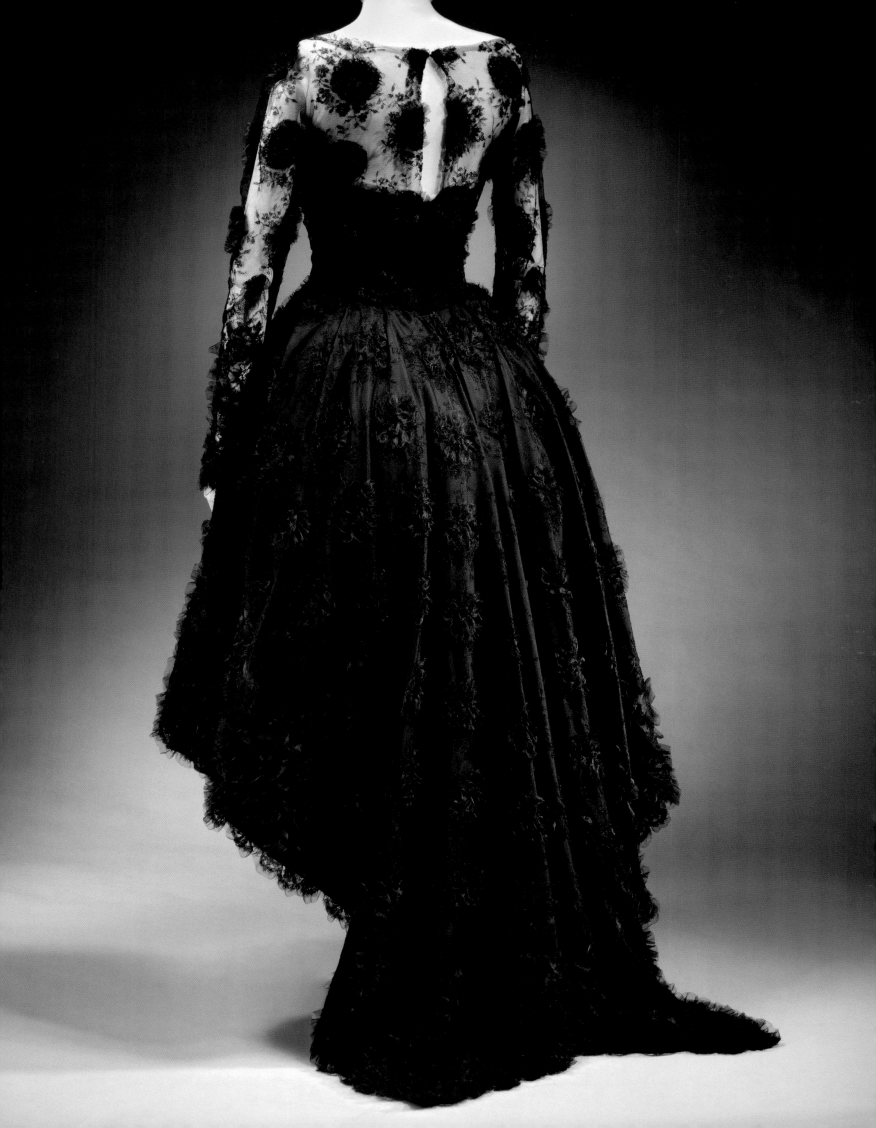

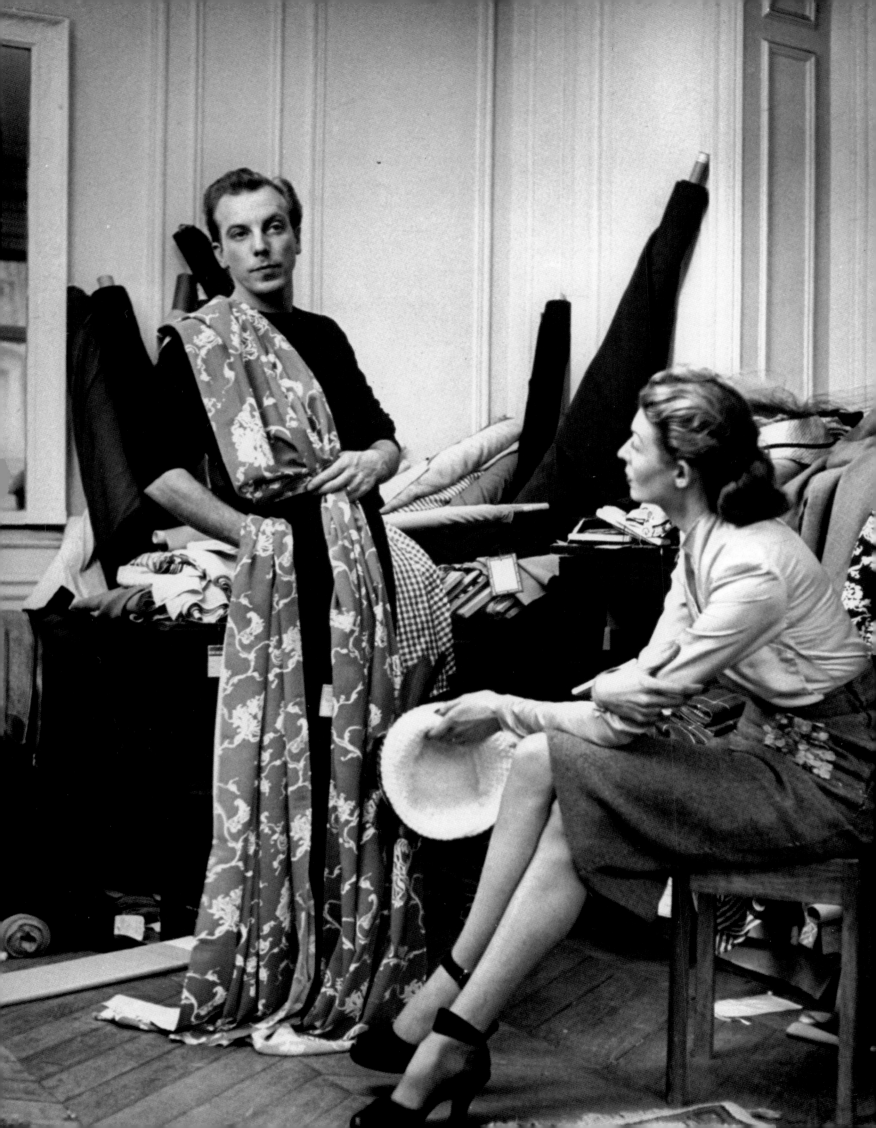

corner, in the middle ground an embroidered or brocaded silk hung seductively across the back of a chair, and artificial flowers lay in boxes on the floor (pl.5.3). Centre stage, the couturier was in the process of draping his model Sylvie in a luxurious, stiff, dove-grey satin, presumably to ascertain how effective that silk would be if cut into one of his highly constructed gowns. The composition captures the sumptuous and expensive veneer of haute couture at this time. Jacques Fath's notion of draping the fabric over himself while his wife Geneviève watched, offered an alternative, youthful, twist to this classic pose, and also favoured a textile of a very different type – a flowing, printed silk with a bold design (pl.5.2).

The plain textiles pictured behind Dior are indicative of the textile staples that couturiers used and thus kept in stock, and suggest the couturier's delight in such quality textiles after years of deprivation during the Second World War. The hand-embroidered fabric and the hand-made artificial flowers are also typical of the traditional luxury embellishments added after the construction of the dress (see p.136). Such surface decoration evolved from season to season in both its textural effects and its motifs, bringing extra novelty to new styles. Machine embroidered and printed patterns were an alternative, screen-printing having freed designers to create painterly surfaces which – after a spell out of fashion – returned as much-valued assets in the couturiers' repertoire from the early 1950s. During this decade, in fact, a huge variety of materials was used for couture garments. This essay reflects on their journey from manufacture to atelier, into the collections and on to the backs of the models, introducing the textiles produced for French haute couture, the relationship the manufacturers had with the Parisian couturiers, and the wider context in which manufacturers and couturiers worked.

Little has been published on these textiles, as fashion historians have tended to concentrate on the cut and style of dress without giving due consideration to its material components.[3] The weight of the most accessible firsthand evidence has perhaps hindered them, for, while couturiers of the 1950s were anxious to publish their memoirs, textile manufacturers were less forthcoming. Moreover, until relatively recently, few museum collections have had strong holdings of mid-twentieth century couture garments or the textiles made for couture. Without accounts from both couturiers and textile manufacturers or documentation of firsthand examination of the textiles and how they functioned in the garments, it is difficult to assess how – or whether – couturiers achieved 'perfect harmony' in the marriage of their design with manufacturers' materials. Fortunately, recent interviews

5.3 Christian Dior with model Sylvie. Christian Dior Archive

have brought to the fore the perspective of the manufacturers and the ways in which they worked with and for couturiers. Research in various museum collections and in company and textile archives is beginning to offer some perspective on the textiles themselves.[4]

An exploration of the role of textiles in couture, embracing their makers as well as their users, merits attention in a book on couture for several reasons. First, the nature of the materials demanded that couture houses cultivate different skills for cutting and manipulation. Two different types of workshop housed those skills – the tailoring (*tailleur*) and dressmaking (*flou*) workshops, the first for the cutting and moulding of stiff and heavy fabrics, the second for the draping and sewing of supple fabrics (see Chapter 3). Secondly, the quantities of material used in each couture garment were large, partly because fashionable styles at this time were voluminous, partly because couture garments were generally lined and interlined, with generous hems and seams. Moreover, if the pattern comprised checks or stripes, or the fabric had pile, extra allowance was necessary to make sure that the checks matched at the seams or that the direction of the nap was consistent. British journalist Alison Settle, writing in 1948, noted the opportunities that the French couturiers gave their textile industry:

> The 'New Look' was launched last year to sell dresses employing up to 30 or even 40 metres of fabric disposed in swirling, swinging skirts, the width pointed up by tightly-corsetted bodies… the 'New Look' spring fashions of 1948… have turned the swirling skirts into skirts which flute. In place of the 30-metre hemlines of last year no more than ten metres are now used. But these ten, of the finest textured materials, are mounted over a stiffening of light tailoring canvas. Backing the stiffening is an equivalent ten metres of satin or taffeta lining; beneath goes at least an equivalent amount of fabric in the shape of a rustling, flounced petticoat. In all, the amount of material used is no less than in the swirl-line skirt. The French textile industry has been given the task of speedily and greatly increasing its exports.[5]

The red evening ensemble 'Zemire', from Dior's Autumn/Winter collection of 1954, confirms this extravagance: its skirt has a circumference of 3.5 metres, a length of 85 centimetres; below the outer layer of crimson cellulose acetate, layered and gathered tulle adds width on each hip, while the skirts are held out by two underskirts, one comprising no less than five layers of tulle, the second comprising silk organza and nylon net panels (see pl.1.9).[6]

As both Alison Settle's description and this garment suggest, the materials that fed demand ensured that this was an intriguing decade, because advances in the production of different qualities and combinations of natural and man-made fibres (cellulose and synthetic) blossomed. The long-lived staples of couture – fine silks and woollens – faced

serious competition as textile manufacturers and pressure groups promoted their wares ever more vigorously, using couture as a vehicle for publicity.[7] The couturiers' choice of textiles could therefore affect the fortunes of textile manufacturers, and consequently the large and hidden workforce that laboured far from Paris.[8] Manufacturers could use sales of high-fashion textiles to couturiers as a springboard from which they could leap into export and domestic markets (comprising high-class ready-to-wear manufacturers as well as professional and home dressmakers). If manufacturers found success with couture houses, they demonstrated their standing in the fashion world and received the orders that helped them to cover their production costs. The fashion and trade press, the sampling houses based in Paris and the fibre-specific lobbying organizations all offered information services to the wider world.[9]

Continuity and Change

Between 1947 and 1957, particular socio-political circumstances pertained in France, some based on a long tradition of state support for the luxury industries, some based on the effects of the German Occupation and some on post-war reconstruction, which embraced valued craft skills and flexible specialization, as well as promoting industrial modernization.[10] In common with most of Europe, France had suffered shortages and rationing in the 1940s, while the Nazis restricted communication with the outside world. Starved of raw materials, French cotton, woollen and silk manufacturers received instructions on the production of man-made fibre from the German administration. After the war, advances in the production of rayon and *fibranne* (spun rayon) were beneficial initially to the woollen industry, which had access locally to old and new raw materials, while the silk industry – not a priority for the modernizers – continued to suffer. Only from about 1948 was there consistent access to raw silk supplies, good-quality colouring agents for dyeing and printing, and power for factory machinery. By 1949, as the impact of monetary aid through the American Marshall Plan was finally felt in France, traditional luxury textile industries stabilized.[11]

During this time, France undoubtedly benefited from its centuries-old reputation for high fashion. This reputation had grown as the result of the state sponsorship of luxury trades since the late seventeenth century, and the formal establishment of haute couture from 1868. Sponsorship had originally focused on the silk and fine woollen manufactures. While France boasted a royal or imperial court in the eighteenth and nineteenth centuries, the state supported the manufacture of luxury goods through the imposition of protective barriers and reductions in import duties, and by providing a platform for the public display of French goods. The French fashion press were willing accomplices in asserting French superiority.[12] This tradition of support surely encouraged the luxury sector to turn to the state in times of hardship. It is unsurprising, therefore, that in 1950, Raymond Barbas, chairman of couture's governing body, the Chambre Syndicale de la Couture Parisienne, proposed a plan that would help both haute couture

'I let the fabrics guide me, and my imagination goes to work as soon as I have put them down'[13]

HUBERT DE GIVENCHY

and the French textile industry. A government subvention would cover the shortfall between the couturiers' investment in new designs and their sales. To qualify for aid, couturiers had to guarantee that 90 per cent of the textiles in their collections would be of French manufacture. In its first year, 1952, textile aid covered 50 per cent of the costs of textiles used in haute couture; from that date until the scheme ended in 1959, it averaged about 30–40 per cent.[14] Significantly, protection for native industries was formally articulated just as foreign imports began to increase: in 1950, the year of Barbas's initial petition, British manufacturers reported with glee a breakthrough in sales of their textiles to French couturiers.[15]

The French fashion press did its best to back native couture and manufacturers. French *Vogue*, for example, remained extremely patriotic in its editorial space well into the 1950s, exclusively featuring the products of the French textile industries. In Spring 1947 the *Cahiers des tissus d'été* ('Notebook of Summer Textiles') was specifically a 'little panorama summarizing the creations of the major French silk and woollen merchants'.[16] In the winter of 1948, when shortages were still an issue, eight woollen merchants and six silk merchants featured in *Vogue*; by 1952, there were 22 in total; by the following year 29; and by 1957, 40.[17] Rogue British and Swiss manufacturers infiltrated this French stronghold after 1953 – in particular, Czech-born textile converter Zika Ascher of London and Hungarian-born textile manufacturer 'Miki' Sekers of West Cumberland Mills, both major creative forces in British textiles, and Abraham and Burg of Switzerland. All were cosmopolitan in their outlook, and had already supplied some couturiers for several years before *Vogue*'s editorial eye alighted upon them.[18] Indeed, Sekers had spent a fortnight in Paris introducing his fabrics to the leading couture houses in December 1949 and predicted both additional work and more exports.[19]

Even before *Vogue*'s editorial space admitted the good quality foreign manufacturers, the magazine accepted advertising revenue from overseas companies. The number of foreign advertisements increased over this decade as textile industries in other countries grew stronger: the British company Jacqmar regularly advertised immediately after the war, and from the end of 1947, textiles from Parenti & Veneroni of Milan, suppliers of the Italian *alta costura*, appeared. In later years, their compatriots Gaetano Marzotto & Figli and Tessito Galtrucco also made a bid for French custom.[20]

While manufacturers advertised independently in *Vogue*, they also engaged in 'tie-ins' with couturiers. In spreads that grew in ambition and number, photographs of particular dresses from named couture houses in textiles from named manufacturers appeared at the beginning of a magazine, sometimes on several consecutive pages. Often the text was simple, merely indicating the name of the couturier, and the name of the textile and its manufacturer. For example, in Autumn/Winter 1949, in the same advertisement Dior and Balenciaga used self-coloured velvet and faille from the silk manufacturers Bianchini Férier of Lyons for two evening dresses (pl.5.4). A black evening dress, 'Cygne Noir' ('Black Swan'), in Dior's Autumn/Winter collection of

gown, and Ascher was influential in persuading Dior to use this fabric for the same purpose for the first time in his Summer collection of 1948. By the following year, Ascher was supplying Balmain, Fath, Griffe, Dessès and Piguet, too.[46] In general, however, cotton sat best for sporty, summer dresses or for blouses and lingerie (pl.5.8). It continued to be associated with youth, and it was usually a light colour, sometimes printed.

Dariaux barely mentioned man-made fibres. Yet both rayon, the first established man-made fibre, and nylon, the 'new kid on the block', played a major role in post-war high fashion, usually combined with natural fibres. Couturiers experimented with what manufacturers offered them. Exotic trademarks, a form of copyright protection, drew attention to such new textiles as Bucol's Cracknyl, Rhodavyl and Tergal. New materials also entered the vocabulary of decoration: plastic ornament vied with traditional glass beads and metal sequins in embroidered patterns, and lurex offered an alternative to gold and silver yarns. Until the mid-1950s the metallic threads used for brocading were still made of strips of silver gilt, which were wound round a silk or cotton core. In woven fabrics, these threads could be used only as wefts, a disadvantage to the manufacturer. The advent of Lurex, a synthetic core with aluminium coated strip, revolutionized the trade, since it could be used for warp and weft. It created the potential for extremely showy products.[47] In 1956 an international exhibition held in New York and London

5.12 Advertisement for the International Lurex Exhibition featuring an evening coat by Fath. *Vogue* (French edition), October 1956

EXPOSITION INTERNATIONALE

LUREX

New-York
Septembre

Londres
Octobre

JACQUES FATH
manteau du soir en lamé
LUREX

testified to its wonders, with fine examples of couturiers' designs to support the claims (pl.5.12).[48]

Fibre was only one component that differentiated traditional and novel couture textiles; texture and pattern were others. The former was generally achieved through the combination of different yarns during weaving, their relative fineness, and the openness of the woven, knitted or netted structure into which the yarns were incorporated. Thus, silk or cotton might convert into a fabric that was transparent and floated ethereally, or was opaque, firm but supple, or could be made into lace. Patterning was created either during or after construction. Lace and brocade effects were created during construction, while the surface of a finished textile could be printed or embroidered afterwards. Initially, after the war, couturiers evidently valued plain rather than patterned textiles, partly because they were used to wartime printed patterns that deliberately obscured the poor quality of the base fabric. From 1946, they sought out fabrics that had some 'body' or 'handle', usually those with dense woven structure. The satin in the photograph of Dior (pl.5.3) belonged to this type of textile, as did the faille and velvet of his black evening gown (pl.5.5), and the taffeta of many of the puffed and draped ball gowns of the early to mid-1950s.[49]

There was a variety of woollen textiles that also met couturiers' exacting criteria for quality: knitted jersey and woven textiles such as tweed, flannel, and wool crêpe. By the late 1940s woollen manufacturers were already combining (sheep's) wool with other animal hair, such as angora, alpaca or mohair, yarns that made the end product lighter-weight, a desirable characteristic for the North American market (always important to Parisian couturiers). 'Chiffon tweeds' and 'crêpe tweeds', much praised in the press, were the culmination of a quarter-century of developments that the war had brutally interrupted.[50] They led logically to the 'froth' of pure mohair and mohair and nylon mixes which, according to the British press, took Paris by storm in 1957. The French press was more restrained in their commentary. Zika Ascher's examples were the result of his collaboration with Scottish mills over the preceding year. Lanvin Castillo unveiled them heroically in a range of huge coats, with romantic names: 'Elsinore', 'Mailcoach', 'Cariolan' and 'McDuff' (pls 5.9 and 5.10).[51]

Pattern entered the equation in woollens in a variety of checks – houndstooth, Prince of Wales, shepherd's plaid and tartans. They were particularly associated with winter and the colour ranges varied from season to season, with *Vogue* evoking particular themes. Fittingly, an article entitled 'Les Grands Crus', which was published in winter 1953, featured these stalwarts of the fashion trade, each colour range associated deftly with the finest wines and spirits: for example, 'noted for that very important evening dress, "Sable d'or", double voile lamé. Lamés from Bucol. Sparkling like champagne'; or 'Noted for travelling, "Silweed", two-toned tweed. Rodier wools with warm glints of old brandy' (pl.5.13).[52] Spots and stripes were perennial favourites, whether woven or printed.

Undoubtedly, as Dior suggested, Spring/Summer was the season for prints. What differentiated couture prints from cheaper products once dyestuffs were readily available was often the number of colours used or the quality of the base fabric on which the colours were printed. Silk, cotton and rayon were the usual base fabrics for printing. While many of the patterns were small in scale, and generally floral, geometric or figurative, truly painterly designs on a grand scale became popular from about 1952. The glorious floral concoctions of chiné roses made for the couture houses by Ascher, Ducharne and Staron, amongst others, epitomize this strain, and remained popular with couturiers till the end of the decade (pl.5.14 and see pl.2.15). There were variations on the theme, the hit of summer 1953 being the 'Blue Bird', a pattern created by Ascher in 1953. It incorporated exotic branches of blossom and diving swallows (pl.5.1).[53]

As mentioned above, these 'visible' materials were the tip of the iceberg, as couture garments are constructed using many 'hidden assets' that are often made of fabric – linings (many were, in fact, visible, and deliberately so), interlinings, padding and

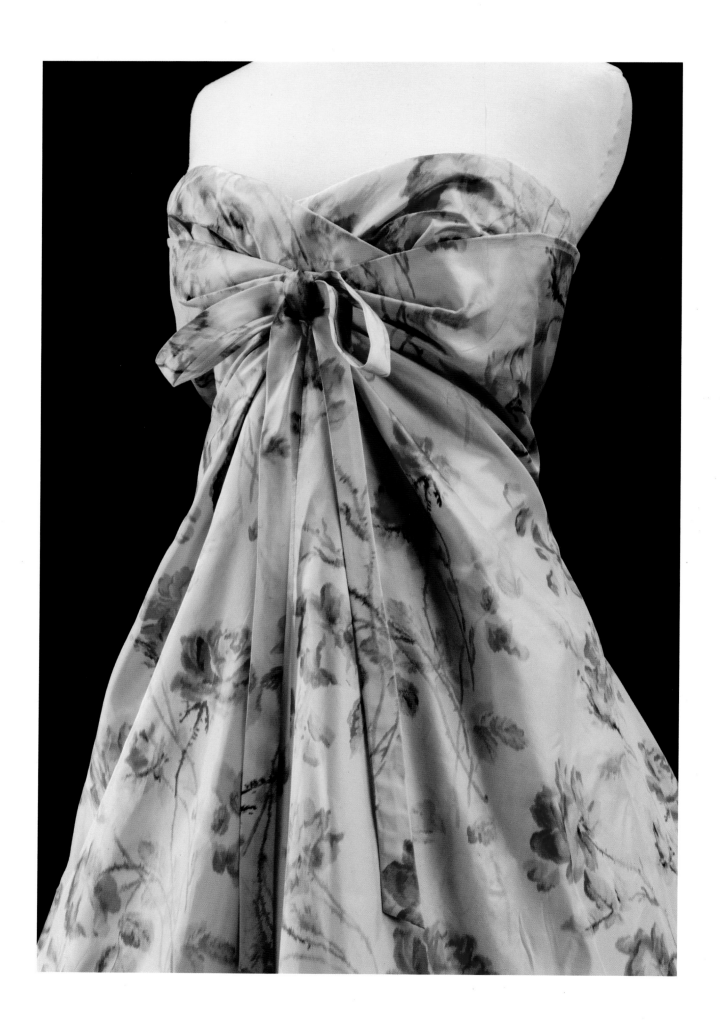

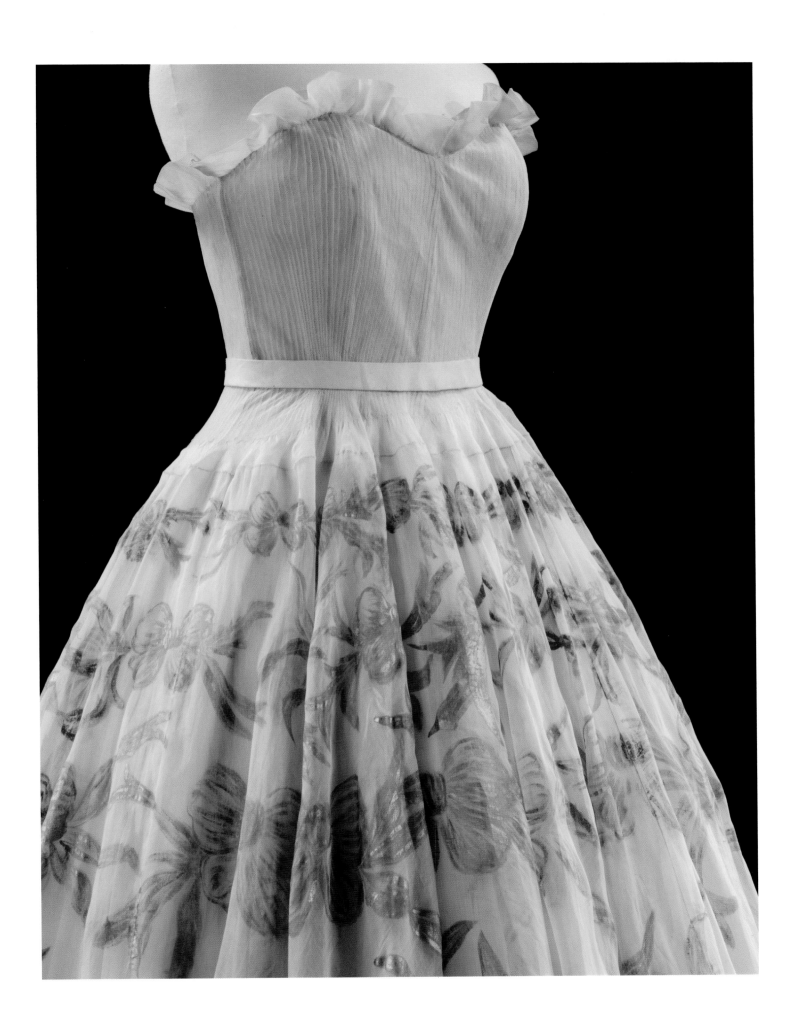

underwear, which by the end of the Fifties was as likely to be made in nylon as in the traditional cotton or silk. As Dariaux observed in the early Sixties, 'No more tortuous whalebones, no more hot rubber materials hugging you affectionately around the waist. The miracle fibres such as Lycra and nylon hold your curves with just as much devotion but without the same inconveniences.'[54] For the unglamorous or invisible, as for the visible components of dress, new materials offered an alternative to the well-established natural fibres (in this case to horsehair, buckram and cotton wadding).

Conclusion

In the post-war years, the French fashion press overtly championed the keen, mutually supportive relationship of couture and French textiles, giving an impression of a stable world of luxury. During this time, however, both couturiers and manufacturers had to adapt to changing social mores and overseas competition. They faced the challenge resolutely, working in their parallel spheres to reach out from the base of couture to wider markets. Just as couturiers sought and found salvation in ready-to-wear, so, too, did textile manufacturers seek and find salvation, in sales to new clients, both at home and abroad, as well as in involvement in other branches of the textile trade, in furnishings, or in new fibre technologies.[55]

The career of Joseph Brochier, the second generation of a silk manufacturing family in Lyons, sums up this adaptation. A member of the Syndicat des Fabricants de Soieries et Tissus de Lyon, the silk manufacturers' trade body in Lyons, he headed one of 184 firms that worked in high-fashion textiles.[56] He pooled his resources with a number of fellow manufacturers in 1947 when he joined the newly formed Groupement des Créateurs de Haute Nouveauté (Group of Creators of High Fashion) which in 1955 went into partnership with the major local chemicals company, Rhodacieta.[57] In fashion history, he is known for his commitment to plain, printed and woven high-fashion fabrics made using both old and new technologies.

However, Brochier also involved himself in seven other categories of manufacture: classic textiles of silk, dyed in the piece or hank; classic rayon textiles, dyed in the piece or hank; textiles for special purposes (including industrial); knitted textiles; furnishing textiles for cars; fashion accessories (scarves, handkerchiefs, etc.); and factory production. He had diversified from 1946 so that, in the year of Dior's New Look, his major achievement lay in two radically different high profile outcomes: white silk for the wedding dress of Princess Elizabeth, and the material that protected the oil pipeline between Paris and Le Havre.[58] Brochier's experience and textiles epitomize modernization in post-war France, yet suggest allegiance to earlier craft traditions. In this period, such flexibility was surely the only possible route to 'perfect harmony' in the 'marriage of design and material' in couture and to economic survival.

5.16 Advertisement for machine-embroidered velvet by Abraham of Switzerland. Evening dress by Christian Dior. *Vogue* (British edition), December 1958

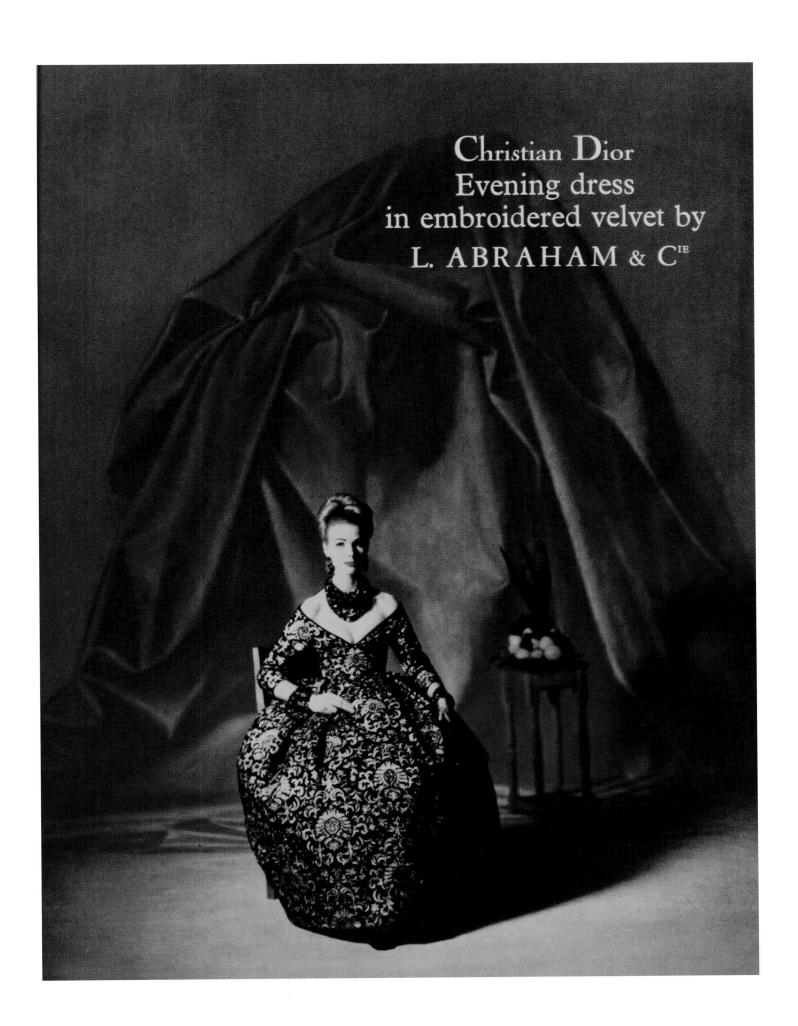

Christian Dior
Evening dress
in embroidered velvet by
L. ABRAHAM & C[IE]

Embroidery

CLAIRE WILCOX

A network of specialized workshops supplied the embellishments and accessories that made haute couture stand out, such as gloves, silk flowers and buttons. At their peak, over 40 Parisian embroidery ateliers – many employing over 100 people – worked tirelessly to provide a range of designs for the couture houses. Most notable were the master embroiderers such as Lesage, Rébé, Vermont and Brossin de Méré in Paris. In London, Norman Hartnell had in-house embroideresses while other London couturiers sent work out to Paris House in Mayfair. François Lesage created roughly 300 samples for each season. These would first be rendered as sketches, then take the form of a precise line drawing which would be pierced through tracing paper. Attached to the fabric, this served as a stencil through which a fine powder could be sifted to mark the outline of the design. The fully embroidered design was shown to the couturiers; if selected, it remained for the exclusive use of the designer. Hubert de Givenchy wrote that often these samples served 'as the springboard to creation'.[1]

Formal evening wear gave free rein to the embroiderers' imagination: this was the time of day and type of occasion at which it was permissible for the couture customer to sparkle. The embroiderers used a variety of natural and man-made materials that gave an added dimension to the fabric: precious and semi-precious stones, crystal, metallic thread, sequins, beads, feathers, raffia and even plastic were used. Dresses selected for embroidery were usually of simple cut and reliant on sumptuous surface detail

to bring them to life. Dior's 'Bosphore' evening dress of 1956 is short and strapless in midnight-blue velvet with delicate embroidery by Rébé which, on closer inspection, reveals velvet birds' nests with clusters of pearl eggs. Couturiers would work with different embroidery houses according to each garment's needs. Dior's formal gown from the 1954 'H' line collection has a formal all-over design of interlocking hexagons worked in couched gilt and silver thread by Brossin de Méré (see pl.2.1). Other designs were bold and dramatic. Lanvin Castillo's cream silk evening gown of 1957 has Lesage chenille-work embroidery in shades of mauve with sequins, beads and stones focused on the bodice, creating a lower, *trompe l'oeil* neckline and leaving the full skirt quite plain.

The consummate skill of the master embroiderers could give the impression that they had scattered gems across the surface of the textile without taking away from its delicacy. Balmain's 1950 evening dress in fine silk organza is sprinkled with silver sequins by Lesage, Swarovski cut crystals and fronds of ostrich feathers by Lemarié. Such a dress would go from one workshop to another, first to be embroidered and then finished with feather-work, a process which could take up to a month. These gowns were seen at their best by artificial light and in grand settings such as the opera or at state occasions. All, however, required meticulous technique and patience, for as Christian Dior explained, 'a ball dress may be entirely covered with millions of *paillettes*, or pearls, each one of which has to be put on separately'.[2]

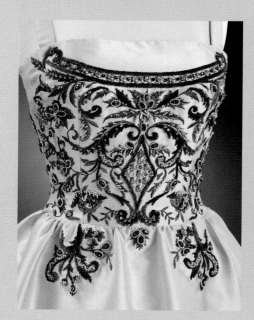

5.17 Evening dress by Lanvin Castillo. Silk with embroidery by Lesage, 1957. Given by the Countess of Drogheda, V&A: T.284–1974

5.18 'Bosphore', cocktail dress by Christian Dior (detail). Velvet with embroidery by Rébé, 1956. Worn by Mrs Stavros Niarchos and given by Mr Stavros Niarchos, V&A: T.119–1974

5.19 Advertisement for Rébé embroiderers. *Vogue* (French edition), March 1952

5.20 Evening dress by Pierre Balmain. Silk organza with embroidery by Lesage, early 1950s. Given by Miss Karslake, V&A: T.176–1969

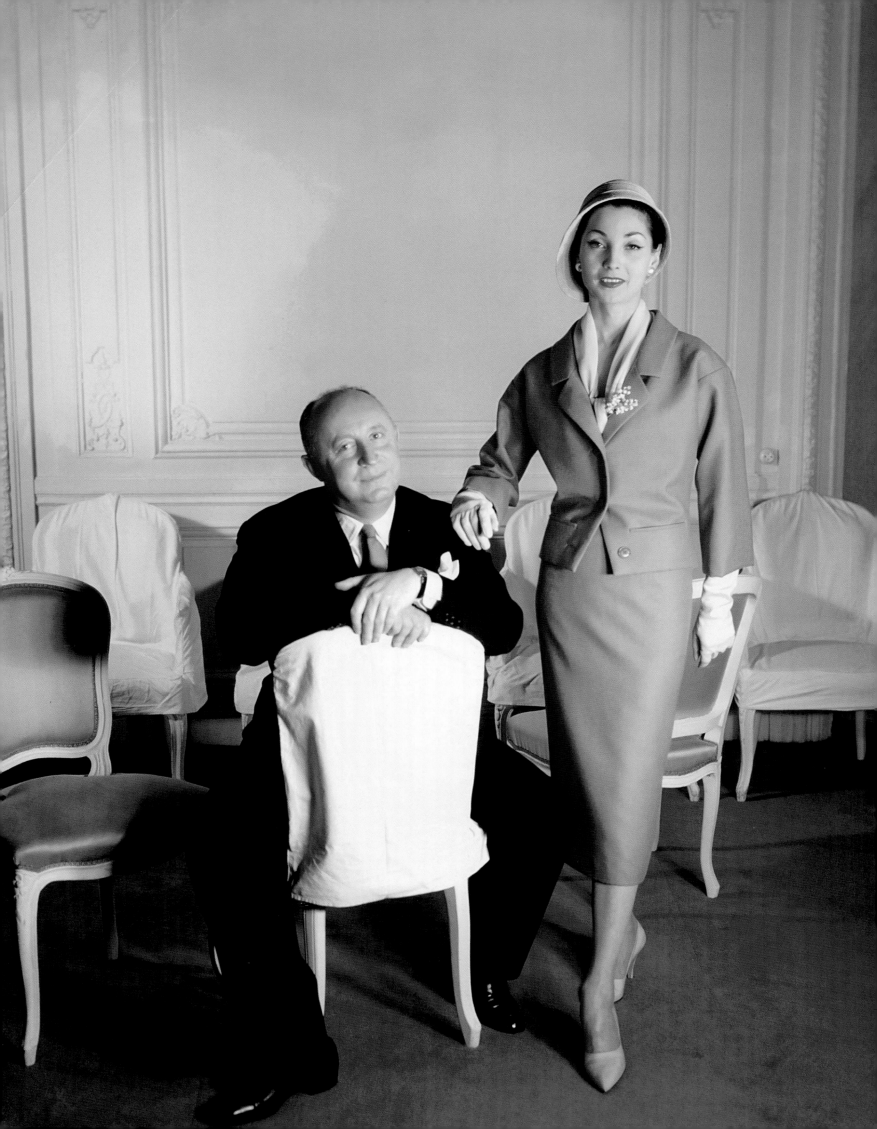

DIOR and BALENCIAGA
A Different Approach to the Body

CATHERINE JOIN-DIÉTERLE

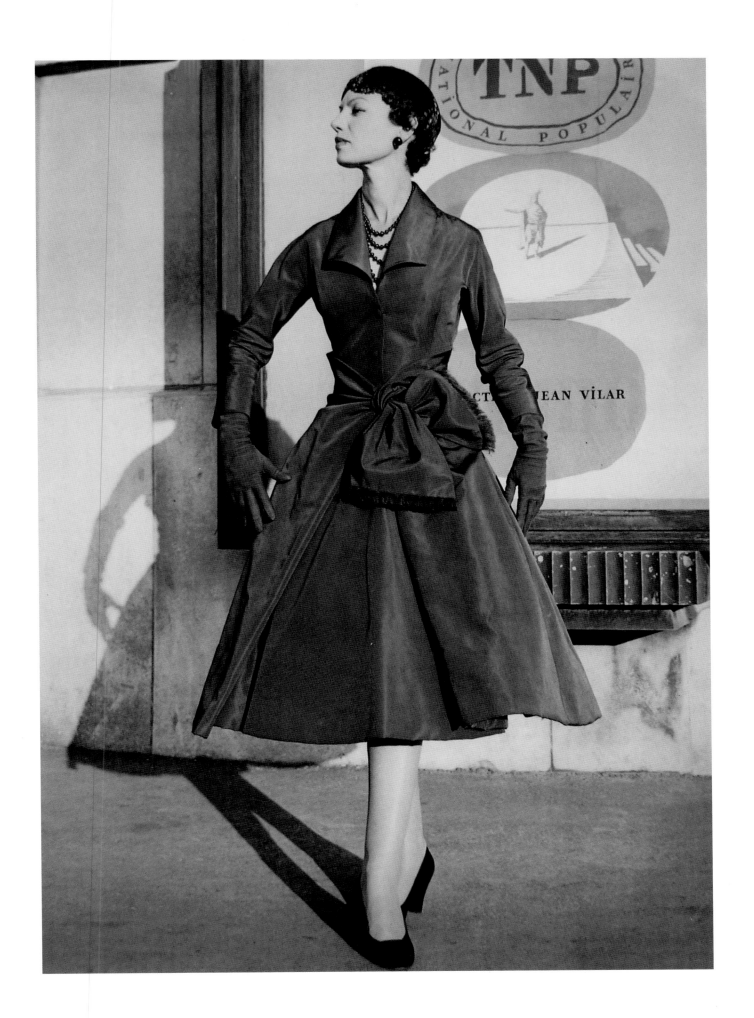

its shape when the wearer moved: comfort and flexibility were the dual imperatives of Balenciaga's designs. Thus he designed suits in which a finger's breadth was left between the garment and the skin, one of the little 'tricks' that he devised as his career developed. The lightness that he cultivated soon became a feature of the period. His colleagues, including Dior in 1954 with his 'French bean' line – a vertical, flattened look – soon followed suit.

Are we do deduce from all this that the creations of these two fashion designers had very little in common? This is actually not the case. Both played with scale and used gigantic elements: examples include the pointed collar reaching down to the skirt of a Dior summer coat of 1950, the huge pointed collar on his winter coat of the same year (see pl.8.10), and Balenciaga's faille bow concealing the bodice of his 1951 guipure lace dress. Similarly, geometric shapes soon became common features of both couturiers' creations, which were probably an unconscious echo of developments in contemporary architecture. In Dior's case, the names he gave his collections after 1954 – 'Figure 8', 'Vertical', 'Oblique', 'Oval' – reflect this, especially in his dress of very pure geometric lines, 'Promesse', in 1957. In Balenciaga's case, this liking for geometric forms, especially the sphere,[26] inspired him to make the garment a kind of envelope separate from the body, an approach that established a connection between his designs and the costumes of the Far East (pl.6.10). Through his avant-garde approach, he opened the way for couturiers such as Courrèges and paradoxically eased the introduction of Japanese designers into France.

However, Dior's search for freedom of movement was a powerful impetus, and was a factor again reflected in the names of some of his collections – 'Flight', 'Zigzag', 'Winged', 'Cyclone' – but this movement is a suspended movement, inherent in the garment, an extraordinary and spectacular swirl highlighted by pleats that often cross over one another (pl.6.11). Leaving aside his 'gypsy' dresses,[27] Balenciaga did not seek motion for its own sake; on the contrary, he was interested in the response of the garment when a woman walked, as can be seen in his 1951 dress with scarves that took flight with the slightest movement. Unlike Dior, whose models viewed in profile were so lively, Balenciaga, who liked to surprise, highlighted the back of his clothes, as is evident in the semi-fitted look of his 1951 suits, and panels that were sometimes detached, sometimes fastened in.

Two very different men, two very different ways of conceiving the creative process and envisaging fashion, according to sensitivities that were, always, of their time. Dior constantly played the fashion game, intuitively understanding the art of staying ahead. Balenciaga's work, on the other hand, bore a sense of eternity, of the reconciliation of past and present.

6.12 Dress with scarves by Cristóbal Balenciaga. Satin and chiffon, 1951

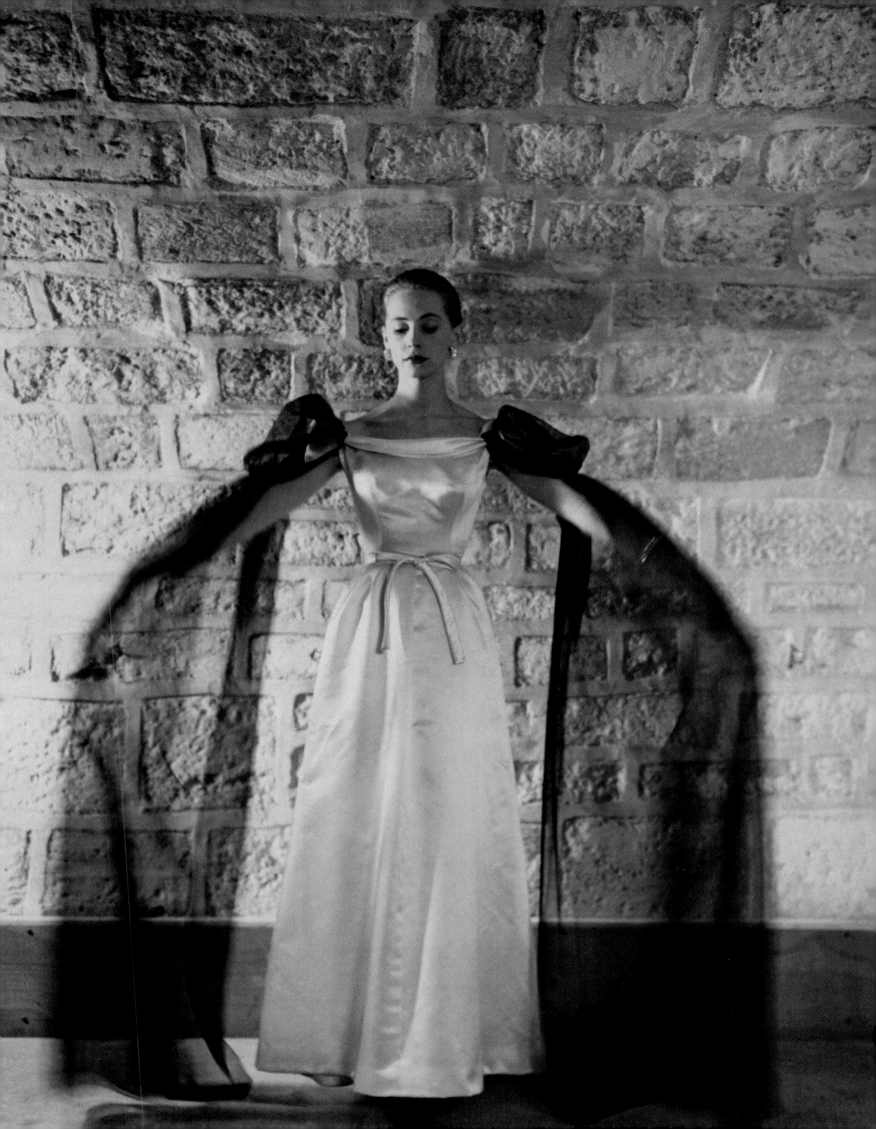

Balenciaga: master tailor

LESLEY ELLIS MILLER

In *A Guide to Elegance*, Geneviève-Antoine Dariaux, *directrice* of the couture house Nina Ricci, wrote: 'A suit is the foundation of a woman's wardrobe... if you have taken care to select a model that is in the long-range general fashion trend rather than a passing fancy, a well-made suit is often wearable for five years or more – especially the Balenciaga models, which are at the same time in advance of the mode and independent from it.'[1]

From 1947 Balenciaga offered two styles: the first fitted and in line with the hourglass shape of Dior's famed 'New Look', the second semi-fitted or loose, an easy alternative that became increasingly fashionable towards the end of the decade and was undoubtedly a precursor of 1960s couture. Balenciaga's perfect little suits commanded high prices: a woollen suit in the early 1950s cost around 110,000 francs.[2] The two suits illustrated are semi-fitted, although constructed in different ways. Both have slim-fitting skirts with a kick pleat that allows ease of movement, and jackets that are broad across the upper body and easy around the waist, based on what fashion journalists called the 'barrel' line.

The first (Winter 1950, no. 24), longer in line than the second, tapers into the hem while the second (Winter 1954, no. 55, made in Henri's workshop for the model Yvonne) is indented at the waist in front but flares out at the back. Both presaged the famous tunic line of 1955 as well as the sack of 1956 (in its ease at the back). Other characteristics are typical of Balenciaga's fascination with cut and construction, as well as his mastery in manipulating firm fabrics. He was adept at creating different types of sleeve and sought perfection in each: the earlier jacket shows Magyar sleeves cut in one with the body while the second has the traditional inset sleeves, made to lie smoothly in exactly the right position on the wearer's shoulder. Balenciaga was renowned in the trade for inspecting and resetting sleeves that were not perfect – even after the garment had been shown in a collection or was being worn by a client. He acquired these exacting standards during his training as a tailor (*sastre*) in San Sebastian: travel guides of this period state appreciation for the skill of Spanish tailors – and the cheapness of their products in comparison with those of the French.

Tweed was a sturdy woollen fabric that appealed to Balenciaga because of the optical illusions created by the two colours in the indistinct flecked pattern. In particular, he was fond of white with brown or black, or even brown and black together, 'the colours of the Spanish earth'. He carefully selected fabrics from the top manufacturers, and for tweeds and woollen fabrics patronized the best in France and Scotland. Although tweed was usually considered appropriate for autumn, these suits had different overtones: the earlier one, with its long sleeves and double-breasted fastening, was far more suitable for outdoor life than the other, whose jacket falls to just below the waist, and whose three-quarter length sleeve allowed ease of movement. The collar is cut away from the neck to let the wearer's pearls breathe.

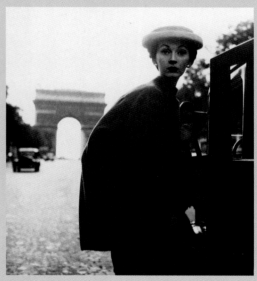

6.13 Suit by Cristóbal Balenciaga, modelled by Dovima. *Harper's Bazaar*, September 1950. Photograph by Richard Avedon. See V&A: T.128–1970

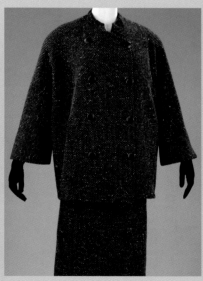

6.14 Suit by Cristóbal Balenciaga. Tweed, 1950. Given by Mrs Catherine Hunt, V&A: T.128–1970

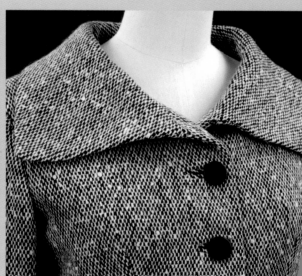

6.15 Suit by Cristóbal Balenciaga (detail). Tweed, 1954. Worn by Mrs Opal Holt and given by Mrs D.M. Haynes and Mrs M. Clark, V&A: T.128–1982

6.16 Suit by Cristóbal Balenciaga. *Vogue* (French edition), September 1954. See V&A: T.128–1982

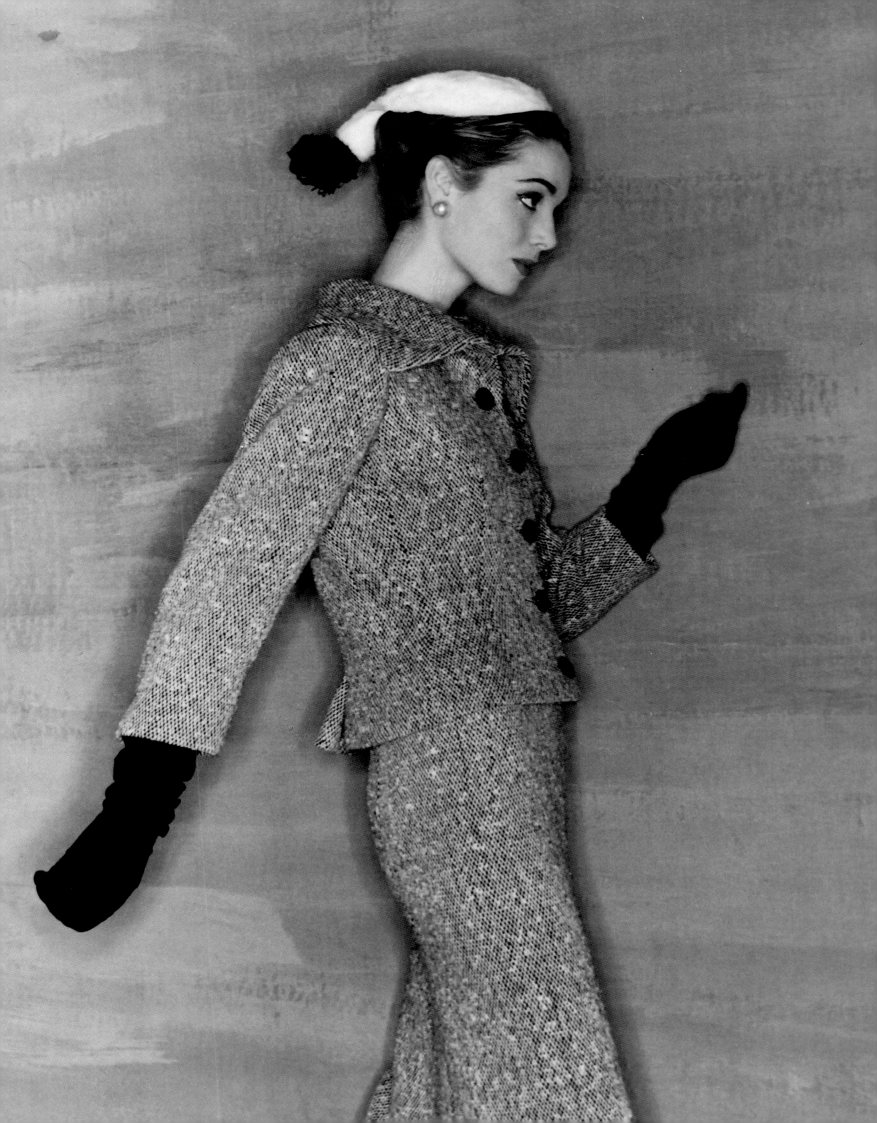

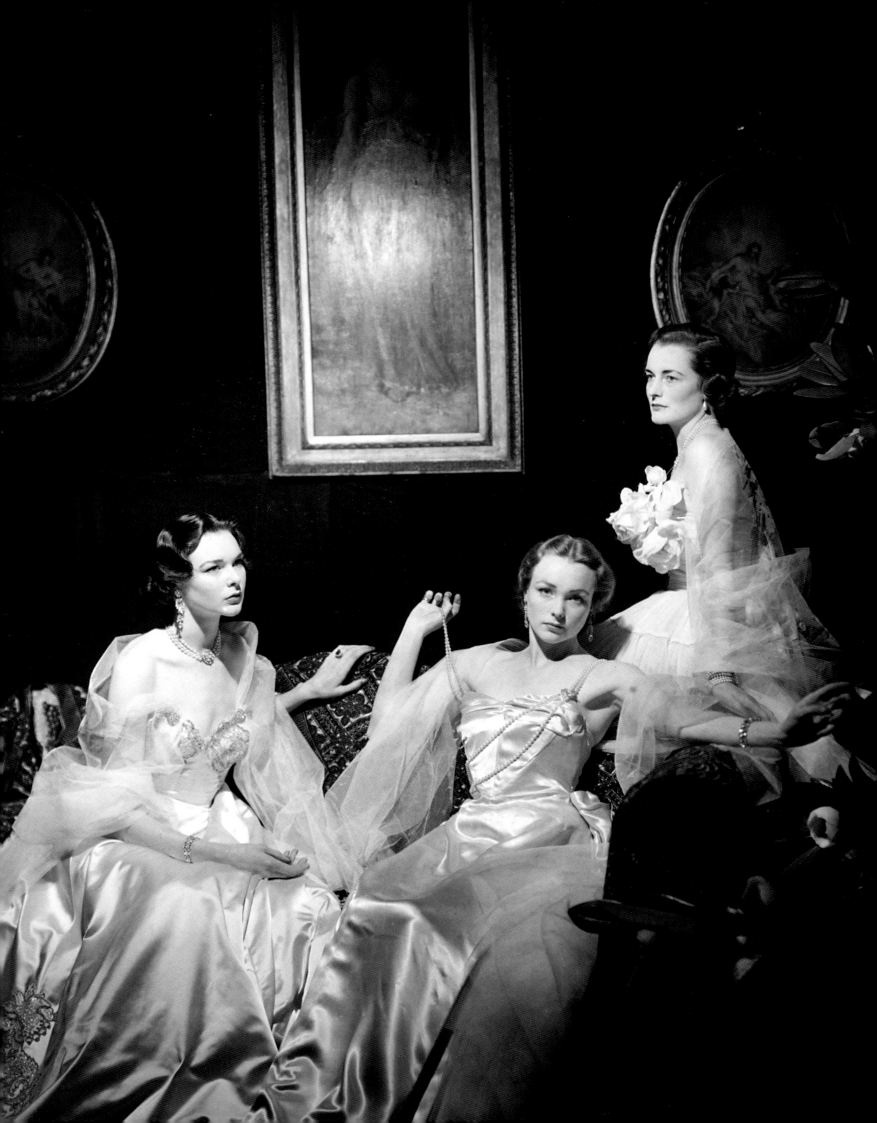

CECIL BEATON
and his Anthology of Fashion

HUGO VICKERS

Dear Cecil,

Let me know when you come to Paris and I will show you what I have! Wonderful idea – it is all vanishing so quickly!

Love Mary.

<div align="right">

BARONESS ALAIN DE ROTHSCHILD, APRIL 1970

</div>

B Y THE 1970s, there were said to be less than 100 women left in the world who commissioned haute couture clothes. Cecil Beaton knew most, if not all, of them, and many were close friends. Thus he was the perfect man to co-ordinate an exhibition of contemporary dresses at the Victoria and Albert Museum in 1971, 'Fashion: An Anthology'. And he went further than that, by creating a permanent collection of couture dresses for the Museum.

Beaton was primarily a photographer, but style was a vital ingredient in every aspect of his work, as important as – and running parallel to – his love of theatre. His involvement in fashion was a close one. It is not every curator who, as an undergraduate, has adorned himself as a woman of style for a theatrical performance at the Cambridge Footlights, who spent much of his youth in fancy dress, and who then went on to dress some of the most elegant women of the day in ballet or theatrical costume. Not for nothing did Beaton's friend, Stephen Tennant, describe him as 'unique in his approach to high fashion… a worldly Peter Pan'.[1] When he dressed Audrey Hepburn for the film *My Fair Lady* (1964), he was aware that normally Hubert de Givenchy dressed her, in life as in previous films such as *Funny Face* (1957) and *Breakfast at Tiffany's* (1961). When Givenchy visited the set of *My Fair Lady* in Hollywood, he amused Beaton by declaring: 'Quel travail! It's like half a dozen collections!'[2]

amongst some earlier pieces, a rare 1946 beaded white satin jacket by Balenciaga.[25]

The story of the Countess of Drogheda (d. 1989) can never fully be told. The former Joan Carr, a talented pianist, looked like a fragile bird, had been a foundling (with no date of birth in her passport), and the mistress of Edgar Wallace. The Droghedas were involved in a curious incident, only publicly revealed years later. When Lady Drogheda was touring America during the war, a Frenchman by the name of Roget fell in love with her. When she was joined by her husband in Washington, this distraught

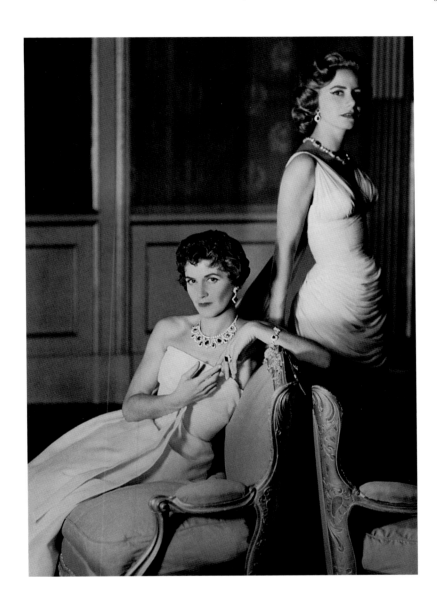

man appeared in the hotel, threatening to stab himself if Lord Drogheda did not allow his wife to go away with him. Drogheda explained that this was out of the question, 'Whereupon, to my astonishment, he drew a knife from his pocket – and stabbed himself in the chest.' He added: 'I had never previously, nor have subsequently, had to contend with such melodramatic behaviour.'[26] When her husband was variously Chairman of the *Financial Times* and the Royal Opera House, Covent Garden, Joan Drogheda was a prominent figure in society. She gave Beaton a 1957 Lanvin,[27] which she described as 'white satin with purple embroidery on the bodice – sounds rather hideous but is in fact pretty [see pl.5.17].'[28]

Lady Elizabeth von Hofmannsthal (1916–80) was one of the Paget sisters, daughter of the 6th Marquess of Anglesey, a Maid of Honour at the 1937 Coronation, and like her aunt, Lady Diana Cooper, one of the most beautiful women in England in her day. She married Raimund von Hofmannsthal (son of Hugo von Hofmannsthal), with whom many English girls were in love. She gave her yellow Balmain evening dress of 1956,[29] and a black Balmain cocktail dress of 1957.[30] After her death her son, Octavian, donated a beautiful

7.11 Eugenia Niarchos (left) wearing an evening dress by Christian Dior, and Athina Onassis, later Marchioness of Blandford, wearing a gown by Jean Dessès. *Vogue* (French edition), January 1957. Photograph by Henry Clarke

Cartier make-up case monogrammed with her initials.[31] It still contains blusher.

Eugenia Niarchos (1926–70) was one of the Livanos sisters, married to the Greek ship owner, Stavros Niarchos (pl.7.11). She was the perfect couture client – beautiful, stylish and exceedingly rich. Beaton had written to Pope-Hennessy that Mme Stavros Niarchos was 'about the only person who could afford to order one of the incredibly beaded dresses that Dior has designed'.[32] Beaton did indeed manage to persuade her to donate her Dior dresses, which thankfully she had 'never had the heart to throw away',

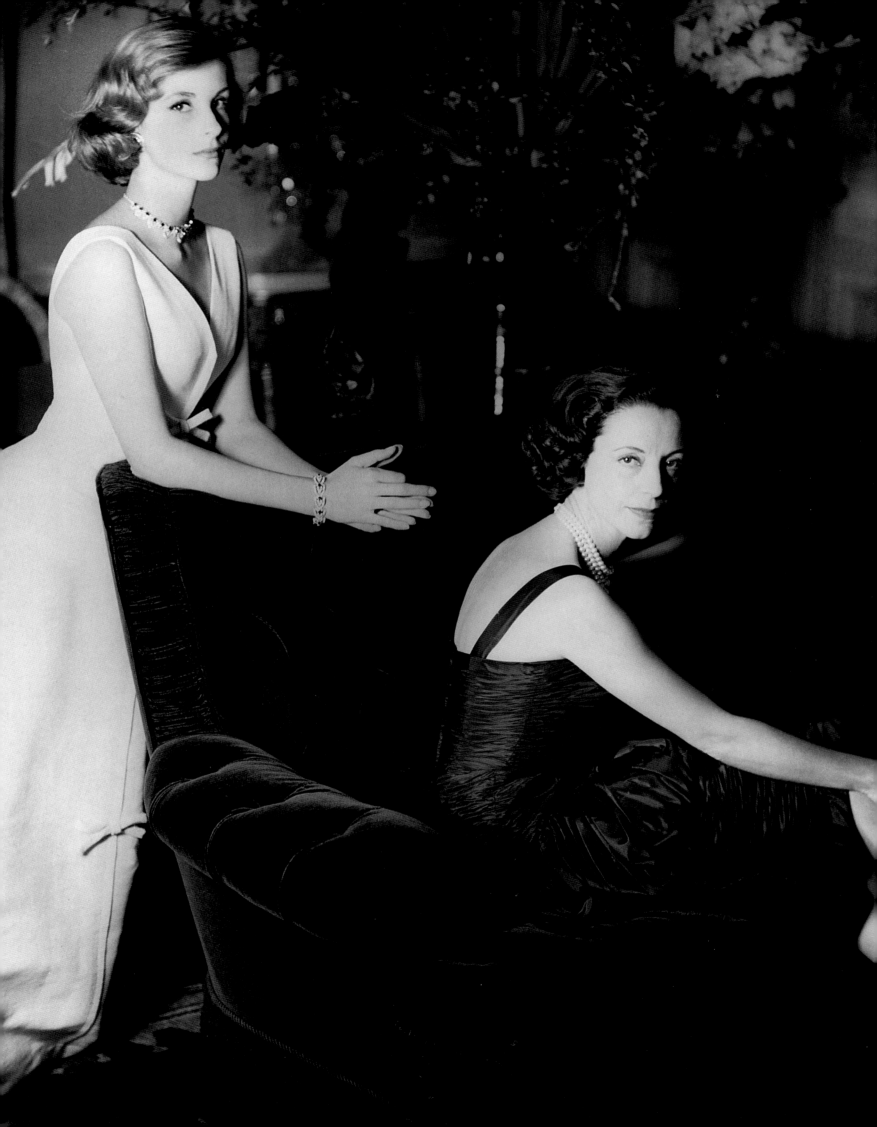

7.12 Mrs Loel (Gloria) Guinness with her daughter Mrs Patrick (Dolores) Guinness, both wearing dresses by Cristóbal Balenciaga. *Vogue* (French edition), January 1957. Photograph by Henry Clarke

7.13 Three of the dresses given to the V&A by Mrs Loel (Gloria) Guinness. Left to right: evening dress by Jeanne Lafaurie. Printed silk with sequins, 1950s. V&A: T.281–1974; evening dress by Christian Dior. Organza with ribbon work and beading, 1954. V&A: T.133–1974; evening dress by Marcelle Chaumont. Hand-painted organza, 1949, V&A: T.92–1974

although she added, 'but I'm afraid they ain't too fresh-looking'.[33] She died on the island of Spetsopoula in May 1970 in mysterious circumstances, and Niarchos then married her sister Athina, later Marchioness of Blandford. After Eugenia's death, Niarchos honoured her promise to Beaton and handed over 19 items, including pieces by Balenciaga, Courrèges, Dessès, Dior, Roger Vivier and Ungaro – most notably Dior's intricately embroidered 'Bosphore' dress of 1956 (see pl.5.18).[34] When I visited Beaton's 1971 exhibition as a youngster, I remember being struck by how small she must have been. The clothes made her sad story seem all the more real.

Mrs Loel Guinness (1913–80) had an extraordinary life. Born in Mexico as Gloria Rubio, her first husband was a Count Furstenberg, to whom she was married at the behest of the German art collector, Freddy Horstmann. Her second husband was an Egyptian by the name of Fakhry, and her third husband, the banker Loel Guinness. In many ways she was unhappy as his wife, as she loved to party and he did not. She gave an enormous number of items from Balenciaga, Dior, Courrèges, Lanvin Castillo, Givenchy, Hellstern and Jeanne Lafaurie, proving that she spread her commissions amongst many different couturiers. Among the 17 outfits, 12 hats and pairs of shoes that

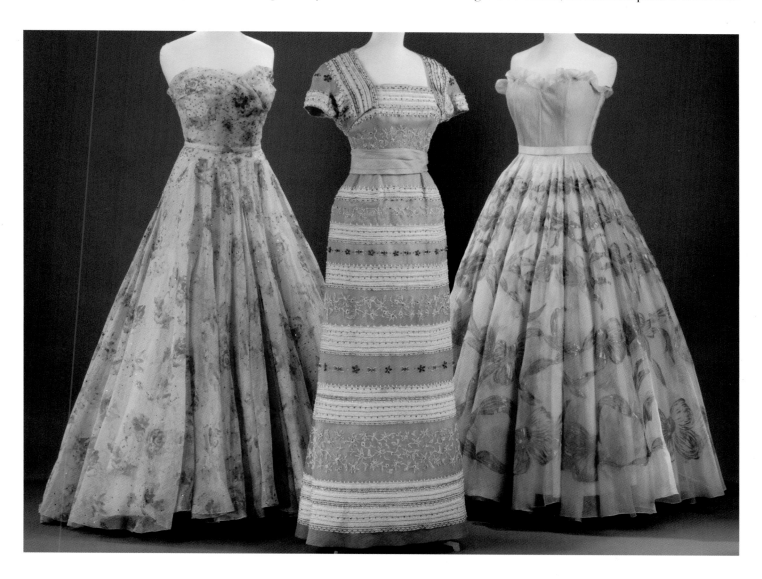

Lady Alexandra

ELERI LYNN

Lady Alexandra arrived in Paris in 1948 as the wife of Captain Howard-Johnston, Naval Attaché to the British Embassy from 1948 to 1950.[1] As an embassy wife she would be expected to attend many dinners and balls for which she would need a glamorous wardrobe, and it was in every couturier's interest to see his clothes represented at these society functions. Jacques Fath was one of the couturiers who most pursued this form of promotion, and he invited Lady Alexandra to be fitted for two complimentary evening dresses and day dresses each season. 'If there was a Fath dress I wanted to keep, I could pay sale price at the end of the season. I was not allowed to go to any other couturier, but I did not want to – Fath was perfection.'[2]

For Lady Alexandra the luxury of Paris was like a fairy tale. She had almost forgotten about fashion during the war, and the rationing that still continued in London. In Paris she could immerse herself in the beauty and bustle of Fath's salon on avenue Pierre 1er de Serbie, where her own *vendeuse*, Madame Dufy (the painter's sister), would attend to her. Not least, she was dressed personally by Fath, who would drape fabric around her, moulding garments to her shape and creating 'the loveliest dresses she had ever worn'.[3] The great event of Lady Alexandra's time in Paris was the official visit of the Princess Elizabeth and

the Duke of Edinburgh in May 1948, for which Fath lent her a sumptuous gown made of cream satin embroidered with amber stones. Arriving at the Théâtre de L'Opéra with her husband, she recalled, 'We started to climb the marble staircase which was lined by the Garde Nationale [when] they suddenly sprang to attention and I realized they had mistaken us for the Princess and Duke. I hurried up the stairs as fast as my dress would allow. That was the effect made by my splendid Fath.'[4]

Lady Alexandra was fortunate enough to share the physique of Fath's models, and she was given some original dresses to wear. One such was a day dress in varying shades of grey, which she wore to the unveiling of a statue in honour of her father, Field-Marshal Earl Haig, in Montreuil-sur-Mer in 1950. The dress was only altered by Fath in order to fit Lady Alexandra during one of her pregnancies. Another dress that Fath created for her was in the Johnston tartan. Fath was well known for his daring use of pattern and colour, and the fabric suited his designs well. Perhaps Lady Alexandra's most precious Fath dress, however, was her wedding outfit in brown wool with gold Lurex threads, created especially for her marriage to Hugh Trevor-Roper in 1954. It was the last dress Jacques Fath made for her, and she wore it for many years afterwards.

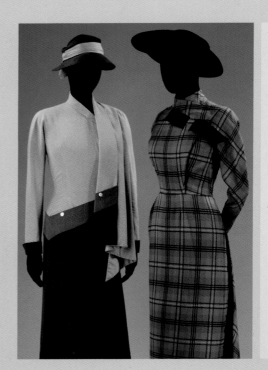

7.15 Two wool day dresses.
Left: 1949, V&A:T.180–1974;
Right: 1950, V&A:T.182–1974

7.16 Letter from Lady Alexandra to Cecil Beaton, 1974. V&A Archives

7.17 Lady Alexandra's wedding dress (detail), 1954. V&A:T.178–1974

7.18 Lady Alexandra in her 1948 state dress by Jacques Fath. Private collection. See V&A: T.184–1974

INTOXICATED
on IMAGES
The Visual Culture of Couture

CHRISTOPHER BREWARD

8.1 Evening dress by Madame Grès,
modelled by Sunny Hartnett. Le
Touquet, France, 1954. *Harper's Bazaar*
(American edition), September 1954.
Photograph by Richard Avedon.
V&A: PH.17–1985

*'the whole world holds its breath,
and scraps of information appear
each day, with little sketches
supplying detail or atmosphere…'*

CELIA BERTIN

THE BEGUILING SURFACES of fashion drawings and photographs produced during the 1940s and '50s provide a rich and justly celebrated iconography of luxurious dressing in the 'golden age' of couture. But beyond the realm of surfaces, as Roland Barthes remarked in his classic thesis on the representation of fashionable dress, until the democratizing trends of the 1960s suggested other modes of operation, such images also played an active role in constituting the 'system' of fashion itself.[1] Their glossy perfection disguised the part they played in ensuring that elite visions translated into wider commercial worth. The standard literature on fashion photography has tended to avoid any consideration of Barthes' insistence on the centrality of image-making to the success of couture as an 'industrial' endeavour, characterizing this material through the art-historical prism of authorship and style. There are any number of beautiful books celebrating the achievements of individual photographers and magazines available, but these will often attempt, intentionally or not, to disguise the 'dirty debt' of their material to fashion's internal structures.[2] By way of redress, in this chapter I depart from such reifying approaches and draw on the published memoirs of those involved in the couture and magazine trades to get a fuller sense of the integral place taken up by image-makers (a term that includes the important interpretative work of editors and art directors) in a complex trade whose deft negotiation of the borderline between reality and dream deserves closer scrutiny.

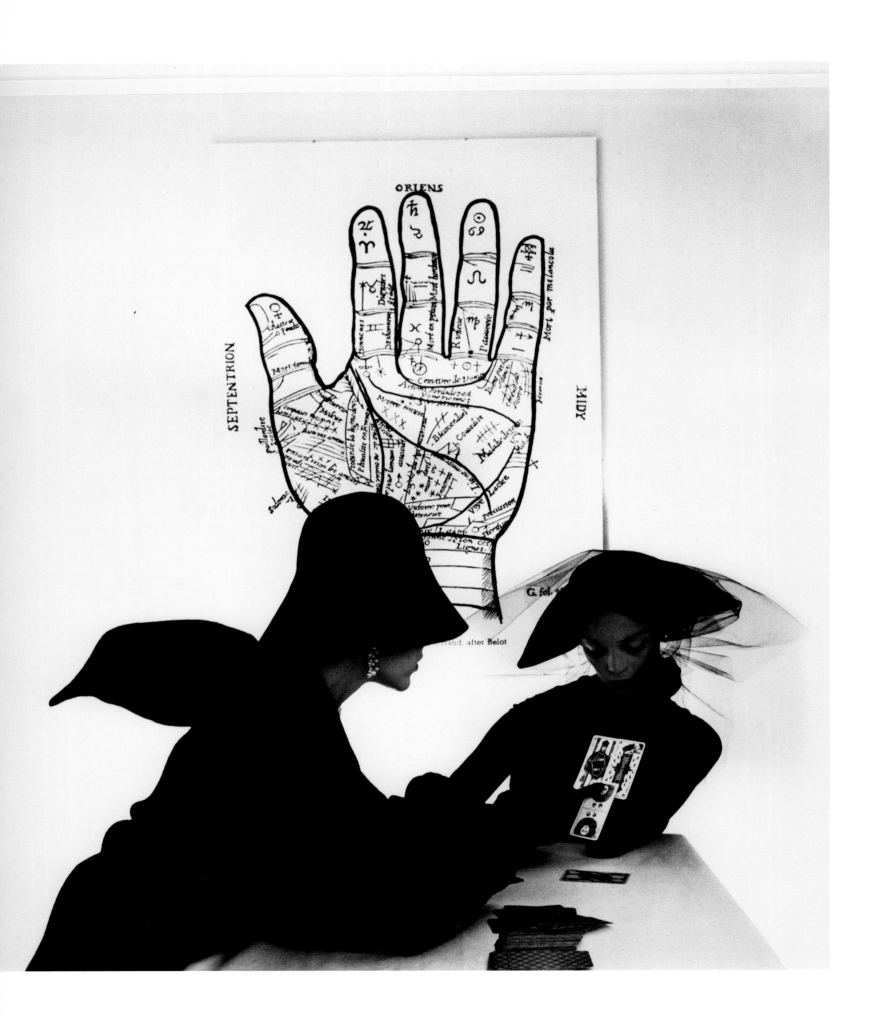

However, an interlude working for the Ministry of Information in the 1940s brought a new realism to Beaton's work, and when he returned as a contract photographer to Condé Nast in 1945 his fashion images reflected a changed professional, social and physical landscape. Models dressed in the neatly tailored couture of the Incorporated Society of London Fashion Designers moved through the bombsites of the capital as if surveying the ruins of that older schema of elegant escapism (see pls 1.2 and 2.2).

The use of the city street as a backdrop was an important theme for several photographers in the late 1940s, and in Paris it was a genre pioneered by Richard Avedon. His pictures of models mingling with the proletarian crowds in the Marais of 1947 and '48 capture the mood of couture at its most bohemian. In one, the notorious aesthete artist Christian (Bébé) Berard, whose word according to Beaton 'could make a hatshop or break a dressmaking establishment',[28] disports playfully with a poodle and the model Renée, swathed in furs and a Dior suit, while in another Elise Daniels, in Balenciaga, strikes a pose that is as contrived as that of the contortionist whose act she has infiltrated (pl.8.13). It is as if the whole carapace of couture's promotional culture is being 'burlesqued', exposed as the performative charade it really is. Beyond bohemian masquerade, these carefully orchestrated *mise-en-scène* representations also expressed something of the economic and psychological investment Americans made in Parisian couture at this time. Historian Anne Hollander identifies in them 'the Jamesian two-way thrill of the American presence in the Old World. Avedon's models in Paris all look like candid Daisys and Isabels... It goes very well with the nineteenth-century flavour of Dior's new designs. Avedon was rendering the haute couture human in the style of great fiction.'[29]

Out of doors this arch masquerade of realism gained some representational power from the combination of grey urban setting and attenuated sartorial elegance: an alchemical reaction where 'Avedon took the bitter French doctrine that life had to be lived for its own sake and applied it to the overabundant American culture of Seventh Avenue, creating in the process a new imagery of the bonheur de vivre.'[30] But once moved inside, the *cinéma-vérité* approach took on further layers that were more directly suggestive of the themes of luxury and artifice that lay at the heart of the couture project. Fashion illustrators were particularly skilled at conjuring up an unsettling world of sensual excess, which

8.11 'The Tarot Reader'. *Vogue* (American edition), October 1949. Photograph by Irving Penn. V&A: PH.929–1987

8.12 'Salad Ingredients'. *Vogue* (French edition), January 1947. Photograph by Irving Penn. V&A: E.1526–1991

> *'Avedon was rendering the haute couture human in the style of great fiction.'*
>
> ANNE HOLLANDER

hinted at the dark secrets of the pornographic novel with its fetishistic details.[31] René Gruau's 1949 drawing for *Fémina*, of a supremely supercilious model in black Balenciaga, imperiously balancing one gloved arm on a luxuriously upholstered golden chair while her scarf trails artfully to the floor, is a typical example, infused with the taut anxiety that often accompanies privilege and elegance (pl.8.14). While illustrations such as this looked back to the powerfully erotic graphic devices of Max Klinger and Aubrey Beardsley, during the 1950s photographers combined this sexualized repertoire with references to filmic melodrama. Avedon's image for the September 1954 edition of *Harper's Bazaar* shows the model Sunny Hartnett in a white jersey Mme Grès evening dress, leaning over the gaming tables at Le Touquet (pl.8.1). In discussing the work, the photographer acknowledged the influence of the classic Hollywood productions of Fred Astaire, but besides the nostalgia, there are also references (perhaps slightly cynical ones) to the artificial mystique of femininity, a mystique that couture deliberately fostered and sought to impose.

It was in the most controversial and avant-garde category of iconographic themes that the visual culture of couture could most profitably engage in the promotion of a mystique that Barthes might otherwise have termed 'fashion'. A tendency towards abstraction in the 1950s was particularly suited to filtering the visual characteristics of couture down to their most concentrated form. For some industry commentators, this trend was unwelcome. Ernestine Carter of *The Sunday Times* regretted that what photographers of the period had striven 'to do was shock and excite, be damned to the clothes they were supposed to be reporting'. For her, 'to photograph a dress so that it is distorted or impossible to see not only betrays the unfortunate designer but denies the equally unfortunate reader the right to be informed' – the ultimate destination of the

8.13 Suit by Cristóbal Balenciaga,
modelled by Elise Daniels.
Le Marais, Paris, 1948. *Harper's
Bazaar* (American edition), October
1948. Photograph by Richard
Avedon. V&A: PH.13A—1985

9.3 Givenchy (Riccardo Tisci), haute couture collection, Spring/Summer 2007

that the couturier's ready-to-wear collections should not be sold at any outlet other than their own boutique, in order to keep Paris fashion as exclusive and grand as possible. Failure to comply with couture regulations still resulted in expulsion from the Chambre Syndicale, but for some couturiers the consequences were no longer deemed important. Pierre Cardin, for example, initiated a contract with the department store Printemps, and was debarred. It was impossible to hold back the democratization of fashion. In 1966, Dior opened its 'Miss Dior' boutique which sold inexpensive youthful designs; in the same year Yves Saint Laurent opened his 'Rive Gauche' boutique on Paris's Left Bank and in 1967 Courrèges launched his boutique, 'Couture Future'.

London's great strength remained in its tailoring traditions. The transformation of Carnaby Street from unremarkable thoroughfare to home of the 'mod' look and, in the 1960s, a mecca for fashion's bright young things was propelled by tailors and boutique owners such as John Stephen who helped to create London's 'Peacock Revolution'.[3] In Savile Row, the couture and tailoring house Hardy Amies survived the 1960s by diversifying into accessories and off the peg menswear lines which married good cut with modern fabrics. Today it remains the sole surviving English house from the post-war decade to create couture – both dressmaking and men and women's tailoring – for private clients in an environment unchanged in spirit since the house's foundation in 1946. Amies's protégé Ian Garlant said of British couture 'it is not about reinventing yourself, but about making you the best kind of you that you can be. Strengthening your own identity.'[4]

9.4 Christian Lacroix, haute couture collection, Spring/Summer 2007

9.5 Jean Paul Gaultier, haute couture collection, Spring/Summer 2003

The synergy between the two cities of Paris and London in the post-war decade was based on an exchange of skills and trade in textiles. It has continued in recent years with the appointment of British designers like John Galliano who have reinvigorated Paris couture, just as incomers such as Balenciaga and Dessès did in 1937. With his appointment to Givenchy in 1996, Galliano became the first British designer since Worth to lead a French haute couture house, soon succeeded by Alexander McQueen, then Julien MacDonald. Chief designer at Dior since 1997, Galliano's virtuoso theatricality has provided the perfect vehicle to demonstrate the technical and stylistic resources that the house can still draw on. In recent years, French-born designers have also become members of the Chambre Syndicale, such as Christian Lacroix in 1987 and '*enfant terrible*' Jean Paul Gaultier, eventually accepted as a permanent member in 1999. Honorary non-Paris based members include Italian couturiers Armani and Valentino, while guest designers including British designer Vivienne Westwood have shown at the couture collections by invitation.[5]

Two of the most important surviving Paris houses from the pre-war period, Chanel and Balenciaga, thrive today by employing different approaches. The cogency of Chanel's brand, based on the designer's original philosophy of function married to exclusivity, has been stabilized and elaborated upon by Karl Lagerfeld since 1983. In recent years, Chanel has purchased several of the most important surviving Parisian workshops that still supply its trademark buttons, camellias and braid, including the embroidery company Lesage and costume jeweller and button-maker Desrues. After years of neglect, the grand house

of Balenciaga has been revived by the appointment of Nicolas Ghesquière in 1997, through the medium of stylish ready-to-wear rather than couture.

The legacy of Dior's 'golden age' is manifold. The rarefied skill of couture in the post-war years set a standard for high dressmaking that has never been surpassed, while the economic and social forces that shaped its production created a sophisticated marketing model that insisted on fashion's constant renewal. Post-war couture is indelibly associated with the New Look, a style that influenced popular fashion in a way that was unprecedented in fashion history, and sixty years on its memory still has great potency. Breathtaking image-making by the great photographers of the time, and the emergence of notable fashion models characterized by their elegance and flawless faces, epitomise an era of heightened

9.6 Chanel (Karl Lagerfeld), haute couture collection, Autumn/Winter 2006–7

femininity. Today, the couture collections are still shown in Paris; often extreme and extravagant, their role is to garner publicity and provide inspiration. Only a small group of loyal clients are still able to afford couture and most of the audience are press, or celebrities who may be lent 'red carpet' dresses for special occasions, while many of the gowns are destined for archive or museum collections. In a discipline where craftsmanship is key, couture's painstaking techniques and anachronisms have been continually passed on, in workshops and cutting rooms and from designer to designer. The metier survives today in a handful of fashion houses, where once there were hundreds, representing a symbolic commitment to artistry and handcraft, that captures in its complexity all the skill and fantasy of the old world of Christian Dior and his contemporaries.

9.7 Givenchy (Alexander McQueen), haute couture collection, Autumn/Winter 1997–8

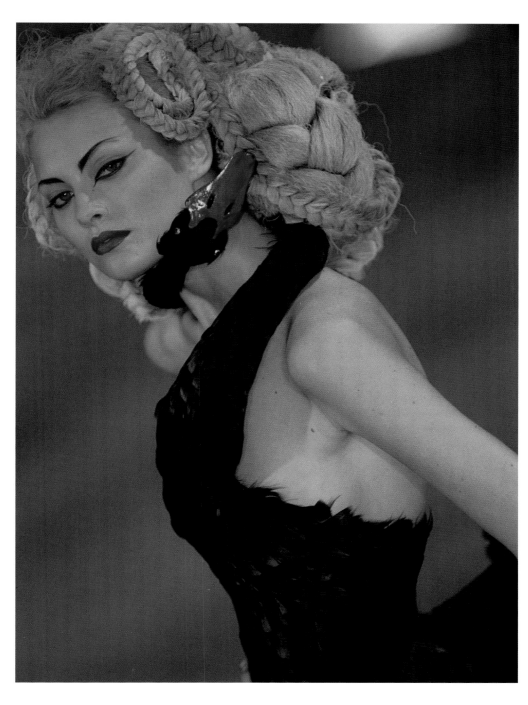

and Paris Run the Breakneck Business of Dressing American Women (New York, 1963), p.162; Alison Settle Archive: Settle, AS L50.6, 1952 report.

36 François Lesage, interview with the author, Paris, 20 May 2006; Olivier Seguret and Keiichi Tahara, Haute Couture: tradesmen's entrance (Paris, 1990), p.30; Jean Vermont, interview with the author.

37 Miller and Picken (1956), p.5.

38 Bertin (1956), pp.109–10; Stanley Karnow, Paris in the Fifties (New York, 1997), p.260.

39 Paul Gallico, Mrs 'Arris Goes to Paris (New York, 1957), p.96.

40 Ballard (1962), p.114.

41 Gallico (1957), p.63.

42 Madame Burait, interview with the author; Dior (1957), p.168.

43 Amies (1954), p.82; Dior (1957), p.168; Miller and Picken (1956), p.23. Bertin (1956), pp.55–70.

44 Sophie Gins, interview with the author, Paris, 20 May 2006.

45 Gallico (1957), p.155.

46 Spanier (1959), p.182.

Jean Dessès

1 Vogue (French edition), December 1939, p.16.

Jacques Fath

1 Bertin (1956), p.210.

2 Equivalent to just under $100,000 in 2005, using the Consumer Price Index. Professor Samuel H. Williamson, 'Five Ways to Compute the Relative Values of a US Dollar amount, 1790–2005' (www.measuringworth.com, consulted April 2005).

3 Life magazine, 19 April 1948.

4 André Ostier, 'Jacques Fath Recalled', in Lynam (1972), p176.

5 Classification Couture – création applications. Archives Nationales de France, Paris, F/12/10.505, cited in Palmer (2001), p.17.

4 Material Evidence

Money comparisons have been kindly provided by the Bank of England. In 1946 £1 was equivalent to £27.01, in 1951 to £21.75 and in 1954 to £18.98, in relation to £1 in August 2006.

1 'The London Way', Vogue (British edition), March 1950, p.77.

2 INCSOC Annual Report 1950, V&A Archives.

See also Palmer (2001).

3 Gordon Beckles, 'These Men Have Flair', The Strand, June 1946, p.65.

4 'Haute Couture in London', The Economist, 4 August 1951, p.270.

5 Ibid.

6 Richard Collier, 'The Fashion Story (3): Eleven Designing Men', Housewife, July 1952, p.99.

7 Amies (1954), p.186.

8 Richard Collier, 'The Fashion Story (3): Eleven Designing Men', Housewife, July 1952, p.99.

9 'Haute Couture in London', The Economist, 4 August 1951, p.270.

10 Amies (1954), p.176.

11 Ibid., p.201.

12 Ibid., p.54.

13 Alison Settle Archive.

14 Amies (1954), p.239.

15 Ibid., p.241.

16 V&A: T.226–1984.

17 V&A: T.214–1976.

18 'Dress Bravely advises designer Paterson', Swindon Evening Advertiser, 21 April 1955 (Paterson Archives, V&A: AAD).

19 V&A: T.312–1987.

20 V&A: T.292–1984.

21 Lilian Hyder, 'Secrets of Fashion No.4: Victor Stiebel and Peter Russell', Woman's Own, 3 April 1952, p.23.

22 Ibid.

23 Lilian Hyder, 'Secrets of Fashion No.1: Norman Hartnell', Woman's Own, 13 March 1952, p.12.

24 V&A: T.192–1973.

25 V&A: T.250–1979.

26 Lindsay Evans Robertson, interview with the author, 16 March 2006.

27 Hartnell (1955), p.101.

28 Video interview with M. Markham, courtesy of The Royal Ceremonial Dress Collection, Historic Royal Palaces.

John Cavanagh

1 The Coronation took place on 2 June 1953. Lady Cornwallis also wore the green and yellow striped Victor Stiebel dress from 1947 described on p.101. In 1948 she married her second husband, Sir Wykeham Stanley Cornwallis, second Baron Cornwallis (1892–1982), and wore a blue-grey figured silk gown by Molyneux, which was also donated to the museum (V&A: T.295–1984).

2 For more on the Countess's dress, see De la Haye, Taylor and Thompson (2005), pp.146–7. For further details about Oliver Messel, see Vogue (British edition), April 19536, pp.132–3.

3 Lindsay Evans Robertson, interview with the author, August 2006.

4 John Cavanagh, interview with the author, Winter 1996, printed in De la Haye (1997).

5 Perfect Harmony

1 Dior (1957), p.73.

2 Ibid., p.68.

3 Exceptions to the rule for couture textiles are: Mendes (1987); Valérie Guillaume's brief article 'Haute couture: reconquête et "new look"', in Philippe Gumplowicz and Jean-Claude Klein, eds, Paris 1944–1954: artistes, intellectuals, publics: la culture comme enjeu (Paris, 1995), pp.96–105; a chapter in Susannah Handley, Nylon: the manmade fashion revolution (London, 1999); and Florence Charpigny, 'L'étoffe de la mode: soierie lyonnaise et haute couture, l'exemple de la maison Ducharne' in Danielle Allérès, ed., Mode: des parures aux marques de luxe (Paris, 2005), pp.30–1.

4 Note in particular the work of Charpigny, Vernus, Blum, Guillaume, Join-Diéterle and Jouve; J.P.P. Higgins undertook interviews for Cloth of Gold: a history of metallised textiles (London, 1993), chapters 7 and 8, as did Pierre Vernus for his unpublished doctoral thesis 'Bianchini Férier, fabricant de soieries (1888–1973)', Université Louis-Lumière (Lyons II), 1997.

5 Alison Settle, 'BACKGROUND OF "NEW LOOK" Bid to Focus All Eyes on French Textile Trade', The Scotsman, Wednesday, 18 February 1948, p.6. A New Look cocktail dress might require 13.5 metres (15 yards) of fabric, while the alternative, slimmer tunic line of the mid-1950s required between 3.5 and 5 metres for a day suit for autumn or for a short summer dress. The suit was made in 140 cm wide jersey or wool in 'Les Patrons de Vogue', in Vogue (French edition), October 1955, pp.134–5, and a short-sleeved, full-skirted dress in 90 cm wide cotton in 'Les Patrons de Vogue', in Vogue (French edition), August 1956, p.104.

6 Approximate metrage (V&A: T.24–2007). Technical analysis of the textiles undertaken by Marion Kite, Textile Conservation and Science Conservation at the V&A.

7 Such as the International Wool Secretariat and the Cotton Board.

8 This is such recent history that very little has been written on the industry. A useful

contextualized introduction is to be found in Pierre Vernus, 'Bianchini Férier, fabricant de soieries (1888–1973)', criticism cited in Taylor and Wilson, (1989), pp.145–51.

9 Often *Vogue* patterns suggested the best textile to buy. For example, 'Les Patrons de *Vogue*' recommended Rodier's jersey for a winter dress in October 1956, and Boucart's real Alsace poplin for a summer dress in August 1957 (*Vogue* [French edition], October 1956, p.128 and August 1957, p.143). In March/April 1957 it even listed all the manufacturers whose textiles could be bought for their patterns in the department store Au Printemps. A number of sampling houses operated from Paris, supplying manufacturers with information about the textiles that were new or proving popular with couturiers and the trade. In this period, from 1949, they included: Textile Paris Echo, 12 rue Gaillon; Claude Frères et Cie., 10 rue d'Uzès; Société des Nouveautés Textiles, 47 rue de Paradis, and Bilbille et cie., rue Réamur.

10 For further insights, see Carlo Poni, 'Fashion as flexible production: the strategies of the Lyon silk merchants in the eighteenth century' in C.F. Sabel and J. Zeitlin, eds, *World of Possibilities: flexibility and mass production in western industrialization* (Cambridge, 1997), pp.37–74; Sabel and Zeitlin, 'Historical Alternatives to Mass Production: politics, market and technology in nineteenth-century industrialization' in *Past and Present*, no.108, August 1984, pp.133–76; Nancy Green, *Ready-to-Wear and Ready-to-Work: a century of industry and immigrants in Paris and New York* (Durham and London, 1997); Rioux (1989).

11 Veillon (2002), pp.69–83; Vernus, op. cit., pp.362–3; Rioux (1989).

12 From *Le Mercure Galant* in the late seventeenth century to the wartime and post-war press. See Jennifer Jones, *Sexing La Mode. Gender, Fashion and Commercial Culture in Old Regime France* (Oxford, 2004); for nineteenth-century, see Elizabeth Ann Coleman, *The Opulent Era* (London, 1989) and Henri Pansu, *Claude-Joseph Bonne: soierie et société à Lyon et en Bugey au XIXe siècle*, tome 1 (Lyon, 2003); and Veillon (2002) on the role of the press during the war.

13 Join-Diéterle (1991), p.59.

14 The sum averaged out at 200 million francs in this period, having started at a high of 395 million in 1952. Grumbach (1993), pp.48–9, 53.

15 *The Ambassador*, 1950, no.2, p.106; no.3, p.104; and no.4, pp.120–7. From the Spring collections Schiaparelli, Molyneux and Fath had favoured English woollens and worsteds, Dior and Balmain, English jersey, Balmain, heavy English rayon coating, Fath shantung and nylon from Zurrer Silks (Darwen) Ltd, Dior, Fath, Balenciaga, Dessès, Schiaparelli, Paquin, Rochas and Lanvin silk brocades and novelty fabrics including woven nylon sheer.

16 *Vogue* (French edition), March/April 1947, p.93.

17 *Vogue* (French edition), October/November 1948, pp.137ff.: Léonard, Lesur, Moreau, Perrot, Pierre Besson, Rodier, Sinclair, Tissus Raimon for woollens, with Rodier having a special interest in jersey; Bianchini Férier, Bucol, Chatillon Mouly Roussel, Ducharne, Guillemin, Staron for silks. *Vogue* (French edition), September 1952, pp.102ff.: the new names were for woollens – Dormeuil frères, Meyer; for woollens and silks, Mougin-Roubaudi-Olré, for new fibre mixes with artificial materials, Guitry, Hurel, Rémond, Robert Perrier, Coudurier-Fructus-Descher. *Vogue* (French edition), November 1953, pp.111ff.; *Vogue* (French edition), September 1957, pp.200–6.

18 Based on a sampling of *Vogue* (French edition) for this decade and on information from the Balenciaga Archives: Balenciaga first bought from Ascher in 1952, from Sekers in 1951 and from Abraham in 1948. Sekers also formed an association, Associated Haute Couture Fabrics, with three other British manufacturers – Otterburn, Jerseycraft and Wain Shiell/Shielana.

19 Letter from Mr Sekers to Werner Stocker, Whitehaven, 10 December 1949. I am grateful to Alan Sekers for coming forward with this evidence.

20 *Vogue* (French edition), December/January 1947–8, p.51. Suppliers of Biki, Casa Rina, Fabro, Fiorani, Gambino Sorelle, Marucelli, Trinelli, Vanna, etc.; *Vogue* (French edition), April 1950 and February 1955, p.25. Nicola White, *Reconstructing Italian Fashion: America and the development of the Italian fashion industry* (Oxford, 2000), in particular, pp.19–31.

21 *Vogue* (British edition), December 1958, p.17.

22 Grumbach (1993), p.49.

23 Dior (1957) p.99; Join-Diéterle (1991); Guillaume (1993), etc.

24 De la Haye and Tobin (1999), p.36. *Vogue* (French edition), July/August 1947, p.4 and October/November 1947, p.21; Chapter 3 of this book. One fashion historian has commented that the extravagance of the New Look was surely motivated by Boussac's desire to sell textiles. The fashion journalist Anny Latour told a tale of the grey cotton dresses of summer 1952. They 'appeared because Boussac had a pile of grey cotton material left in his warehouses', Latour (1958), p.219.

25 A tradition that stretched back to the eighteenth century and continues into the twenty-first. Nicolas Joubert de l'Hiberderie, *Le dessinateur pour les étoffes d'or, d'argent et de soie* (Paris, 1765), Introduction; Latour (1958), p.217.

26 Balmain to Hureau, 11 July 1960, cited in Vernus, op. cit., p.393; Vernus, op. cit., p.394.

27 Dior (1957), p.69.

28 Golbin (2006), p.18; Charpigny, op. cit., pp.29, 32.

29 Blum and Haughland (1997), pp.125, 263–4. Charpigny, op. cit., p.33.

30 Join-Diéterle (1991), p.62.

31 Higgins (1993); Golbin (2006), p.98.

32 V&A: T.24–2007. Dior's 'Zemire' bears the name Sekers on the label and Lady Sekers' son, Alan, confirms the close friendship of Miki Sekers and Dior; Demornex and Jouve (1988), p.107.

33 Cited in Handley, op. cit., pp.79, 82.

34 Faith Shipway, 'Nylon News in Lace and Lingerie', *Skinner's Silk and Rayon Record*, November 1951, p.1572.

35 Ducharne, cited in Charpigny, op. cit., p.31.

36 Latour (1958), p.218. According to Latour, the couturier's choice was protected for six months, during which time he had exclusive use of a particular textile.

37 Charpigny, op. cit., p.30.

38 Ducharne thought that eight colours were quite sufficient (Charpigny, op. cit., p.34), but this is three to four colours more than what is normally used today for commercial prints.

39 Dior (1957), p.69.

40 *Almanach ou Annuaire commercial de Paris*, 1947–55.

41 Grumbach (1993), p.47. As distinct from the Sentier where the suppliers of textiles for ready-made clothing were located.

42 In the Post Office Directories they featured variously under the rubric of textile manufacturers, agents or merchants (*Post Office Directories*, 1953 and 1957). They were: Coudurier, Fructus et Descher, Dormeuil frères, Ducharne (E.) et cie., Dumas et Maury, Hurel,

Léonard (W.), Meyer (E.), Rodier, and Staron.

43 As early as 1898 Bianchini Férier had opened its first branch in Paris. The success of that office led to the establishment of others in other fashion capitals: in London (1902), in New York (1909), in Montreal (1922), in Brussels and Geneva (1931), and in Dusseldorf (1940). By 1947 the firm had added Buenos Aires to the list. Other manufacturers followed suit. Henriette Pommier et al., *Soierie Lyonnaise* (Lyons, 1980), p.63, and Vernus, op. cit.

44 Lou Taylor, 'De-coding the Hierarchy of Fashion Textiles', in Taylor (2003), pp.67–79. She uses Pierre Bourdieu's seminal framework from *Distinction: a social critique of the judgement of Taste* (1979).

45 Geneviève Antoine Dariaux, *A Guide to Elegance* (reprinted edition, 2003), pp.83–97, 182. It was originally published in 1964, but based on the mores of the previous decade.

46 Blum (1997), p.251; Mendes (1987), p.106.

47 'Trademark of the Dow Badische Company for its metallic fibre yarn, which was introduced during the 1940s. Woven or knitted with cotton, nylon, rayon, silk or wool fibres, Lurex is made into dresses, cardigans and sweaters. It is particularly suitable for eveningwear and was popular until the 1970s.' *Thames and Hudson Dictionary of Fashion and Fashion Designers* (London, 1998).

48 *Vogue* (French edition), October 1956, advertisement (opening pages).

49 Guillaume, op. cit., p.101.

50 'Featherweight Tweed Weights Capture World Markets', *Daily Telegraph*, 21 October 1947; 'New York Turns on the Heat', *Glasgow Evening News*, 17 October 1947; R.M.S. Nairn, 'New Look Line and Shape Opportunity for Scotch Tweed Trade', *The Scotsman*, 14 April 1948.

51 Mendes (1987), pp.112–19.

52 *Vogue* (French edition), September 1953.

53 Mendes (1987), p.108.

54 Dariaux, op. cit., p.100.

55 Such as the department store Galeries Lafayette and ready-to-wear manufacturing firms. Grumbach (1993), pp.54–5; Florence Charpigny and Michèle de la Pradelle, 'La fabricaton du luxe: l'exemple de Bucol, maison de soierie lyonnaise', in *Les Cahiers de la Recherche. Luxe-Mode-Art*, no.2, 2003, pp.31–7.

56 The Syndicat comprised 429 individual firms in total. Syndicat des fabricants de soieries et tissus de Lyon, *Compte rendu 1956* (Lyons, 1956), pp.9–11.

57 Bernadette Angleraud and Catherine Pellissier. *Les Dynasties Lyonnaises*, *Des Morin-Pons aux Mérieux du XIXe siècle à nos jours* (Paris, 2002), p.652. Rhodacieta had made enormous strides during the war in the development of new synthetic fibres. This partnership lasted into the early 1970s.

58 Ibid., p.658.

Embroidery

1 Palmer-White (1987), p.12.

2 Ibid., p.79.

6 Dior and Balenciaga

1 Hubert de Givenchy, interview with the author, April 2006.

2 Dior (1951), p.19, cited in Musée Christian Dior (2005).

3 For the financial aspect of haute couture, see Grumbach (1993).

4 Dior (1956), p.75.

5 Comment by Susan Train, quoted by Pochna (1994), p.176. American journalist Susan Train worked for both French and American *Vogue* from 1947, and was awarded the Chevalier of the Order of Arts and Letters in 1990.

6 Miller (1994), p.26.

7 A silence that is due as much to his character as to a marketing policy; see Miller (1994), p.14.

8 The only interview Balenciaga granted was with Prudence Glynn, a journalist at *The Times* in August 1971.

9 *Conférences écrites par Christian Dior for the Sorbonne, 1955–57* (Institut Français de la Mode: Paris, 2003)

10 Ibid., note 2. Interviews published by *Elle*.

11 Ibid., note 4, p.27.

12 Ibid., note 10, p.235.

13 Unlike Dior who, in his youth, moved in the same circles as some of his future clientele, Balenciaga arrived in Paris knowing nothing of the clothing habits of ski enthusiasts, and would sit for hours in the Palace de Saint-Moritz watching the fashionable set, then spend the night in the station before returning to Paris. Hubert de Givenchy, interview with the author, April 2006.

14 He said to Hubert de Givenchy, who expressed surprise at his choice of models, 'Show me a bent back, I'll unbend it!'. Hubert de Givenchy, interview with the author, April 2006.

15 Balenciaga said to one of his models, 'You are too beautiful'. Hubert de Givenchy, interview with the author, April 2006.

16 Hubert de Givenchy, interview with the author, April 2006.

17 'I made it a rule never to set foot in my salons, never to intervene directly in the business, to see my customers only rarely. One's closest friend... is thus free to order or not.' Dior (1956), p.172.

18 Ibid., note 6, p.35.

19 *Dépêche commerciale*, 1939, cited in Flory (1986), p.61.

20 When he didn't like the armhole on friends' clothes, Balenciaga often took to dismantling the sleeves; see Demornex and Jouve (1989), p.74; Givenchy also experienced this on several occasions, Hubert de Givenchy, interview with the author, April 2006.

21 V&A: T.234–1982.

22 I do not share the view expressed by Garnier (1987): 'Both vigilantly practised the art of remodelling the body through the impeccable architecture of their garments.' This article also contains a very interesting comparison between the forms of the dresses and those of certain insects.

23 The poet Stéphane Mallarmé, owner and editor of a fashion magazine, wrote 'this armour bodice was already introduced a year ago'. *La dernière mode*, September 1874.

24 Flory (1986), p.25.

25 There are even those who have implied that Balenciaga 'detested the woman's body and concealed it. He dressed them all like old women'. Alex Liberman, cited in Pochna (1994), p.232.

26 For example, the 1950 'balloon' dress and cape, and the 1957 designs.

27 For example, the dress designs of 1951.

Balenciaga: master tailor

1 Dariaux, op. cit., pp.83–97, 182.

2 Taken from a bill from the Phoenix Museum of Art gallery guide, March 1950.

7 Cecil Beaton

1 Vickers (1985), p.xxiii.

2 Ibid., p.471.

3 Cecil Beaton to Pope-Hennessy, 14 October 1969 (V&A Archives).

4 Beaton to Pope-Hennessy, 14 October 1969 (V&A Archives).

5 Pope-Hennessy to Beaton, 17 October 1969 (V&A Archives).

6 Draft letter, undated, but 1969 (V&A Archives).

7 Beaton to Pope-Hennessy, 11 November 1970

(V&A Archives).

8 Pope-Hennessy to Beaton, 7 December 1970 (V&A Archives).

9 Ernestine Carter, *The Magic Names of Fashion* (London, 1980), p.2.

10 Beaton (1971), p.7.

11 Princess Lee Radziwill gave 13 outfits and seven hats.

12 V&A: T.464–1974.

13 Michael Wishart to the Hon. Stephen Tennant, letter in possession of the author.

14 V&A: T.4–1974.

15 Jebb (1995), p.206.

16 Although Jacques Fath died in 1954, his business survived for a few years, managed by his widow Geneviève.

17 A 1958 Yves Saint Laurent cocktail dress for Dior, entitled 'Bal Masque', V&A: T.125–1974.

18 Duchess of Windsor to Beaton, 17 July 1971 (V&A Archives).

19 V&A: T.397–1974.

20 V&A: T.116–1974.

21 V&A: T.113–1974, T.114–1974.

22 V&A: T.46–1974.

23 V&A: T.48–1974.

24 V&A: T.52–1974.

25 V&A: T.15–1974.

26 Lord Drogheda, *Double Harness* (London, 1978), p.92.

27 V&A: T.284–1974.

28 Countess of Drogheda to Beaton, April 1971 (V&A Archives).

29 V&A: T.49–1974.

30 V&A: T.51–1974.

31 V&A: T.62–2004.

32 Beaton to Pope-Hennessy, 14 October 1969 (V&A Archives).

33 Mme Stavros Niarchos to Beaton, Villa Marguns, St Moritz, 9 April 1970 (V&A Archives).

34 V&A: T.119–1974.

35 V&A: T.16–1974.

36 V&A: T.245–1974.

37 Vickers, Hugo, ed., *The Unexpurgated Beaton* (London, 2002), p.117.

38 V&A: T.246–1974.

39 Lord Mountbatten to Beaton, 2 November 1971 (V&A Archives).

Lady Alexandra

1 Lady Alexandra Haig (1907–97) was the daughter of Field-Marshal Earl Haig. She married, firstly, Captain (later Rear-Admiral) Howard-Johnston in 1941. Following their divorce in 1954 she married the historian Hugh Trevor-Roper, who was created Baron Dacre of Glanton in 1979.

2 Lady Alexandra Dacre, *Memoirs* (private collection: unpublished), p.328.

3 Ibid., p.327.

4 Lady Alexandra Dacre, family letter, 1994.

8 Intoxicated on Images

1 Barthes (1990).

2 See, for example, Devlin (1979); Nancy Hall Duncan, *The History of Fashion Photography* (New York, 1979); Martin Harrison, *Appearances: fashion photography since 1945* (London, 1991).

3 Dior (1957), pp.60–1.

4 Ibid., pp.61–2.

5 See Jean Dawnay, *How I became a Fashion Model* (London, 1958), pp.50–1, for a description of Dior at work during this stage of the design process.

6 Dior (1957), p.63.

7 Dior may have insisted on the importance of drawing to the craft of couture, but as Claire Wilcox has pointed out, Balenciaga took the opposite view and followed Madeleine Vionnet's practice of three-dimensional rendering.

8 Francis Marshall, *Fashion Drawing* (London, 1955), p.60.

9 Miller and Picken (1956), p.144.

10 Bertin (1956), p.35.

11 Miller and Picken (1956), p.145.

12 Bertin (1956), pp.35–6.

13 Ballard (1960), p.236.

14 Dior (1957), p.117.

15 Ballard (1960), pp.122–3.

16 Ibid., p.170.

17 Amies (1954), pp.215–16.

18 Ballard (1960), p.265.

19 Miller and Picken (1956), p.149.

20 Irving Penn, *Passage: a work record* (London, 1991), p.80.

21 Marshall, op. cit., p.62.

22 Dior (1957), p.28.

23 Ibid., p.57.

24 Henry Yoxall, *A Fashion of Life* (London, 1966), p.101.

25 Ballard (1960), p.47.

26 Penn, op. cit., p.26.

27 Martin Maux Evans, ed., *Contemporary Photographers* (New York, 1995), p.511.

28 Beaton (1954), p.221.

29 Richard Avedon, *Woman in the Mirror* (New York, 2004), p.239.

30 Adam Gopnik, 'The Light Writer' in Mary Shanan, ed., *Richard Avedon: Evidence 1944–1994* (New York, 1994), p.111.

31 The uniquely sensual quality of the fashion drawing was sometimes also emphasized through its reproduction on textured or coloured paper, differentiating it from other sections of the magazine.

32 Carter (1974), pp.113–14.

33 Avedon, op. cit., p.239.

34 Martin Harrison, 'A Life in Images' in Catherine Chermayeff, Kathy McCarver Munchin and Nan Richardson, eds, *Lillian Bassman* (Boston, 1997), p.53.

35 Gopnik, op. cit., p.111.

36 Maux Evans, op. cit., p.60.

37 Bertin (1956), p.42.

38 Such tensions are also compellingly represented in the inevitable triumph of the more democratic photograph over the traditional illustration in magazines by the end of the 1950s.

39 See Gilles Lipovetsky, *The Empire of Fashion: dressing modern democracy* (Princeton, 1994), pp.80–1.

40 Roland Barthes quoted in Michael Carter, *Fashion Classics: from Carlyle to Barthes* (Oxford, 2003), p.149.

Richard Avedon

1 From Richard Avedon, 'Borrowed Dogs', printed in *Grand Street* (Autumn, 1987), pp.52–64. The essay is adapted from a talk delivered by Avedon at the Museum of Modern Art, New York, 27 September 1986.

9 Legacy

1 Lynam (1972), p.241.

2 Ibid., p.242 and Taylor and Wilson (1981), p.177.

3 See Chapter 4 in this book, p.163.

4 In conversation with the author, April 2007.

5 'Guest' designers, who may not meet the strict requirements for entrance to the Chambre Syndicale de la Couture Parisienne, are annually invited to participate in the shows. The list varies from year to year.

Index

Illustration Credits

Images and copyright clearance have been kindly supplied as listed below. Unless otherwise stated below or in the captions, images are © V&A Images.

2.7, 2.25, 8.1, 8.2, 8.13, 8.15, 8.20: Copyright © 2007 The Richard Avedon Foundation

1.6, 4.11, 7.14: Cecil Beaton/Vogue © The Condé Nast Publications Ltd

2.26: Christian Bérard. © ADAGP, Paris and DACS, London 2007/Vogue Paris

2.3, 2.4, 2.5, 3.18, 6.10: Bibliothèque nationale de France

8.22, 8.23, 8.24, 8.25: Blumenfeld/Vogue © 1952 Condé Nast Publications Inc.

4.3: Bouché/Vogue © The Condé Nast Publications Ltd

2.16: Henry Clarke © ADAGP, Paris and DACS, London 2007/Vogue Paris

2.18 CORBIS/Henry Clarke © ADAGP, Paris and DACS, London 2007

Front jacket/cover, 1.2, 8.10: Clifford Coffin/Vogue © The Condé Nast Publications Ltd

1.10: Clifford Coffin © Vogue Paris

7.11: © Condé Nast Archive/CORBIS

3.6, 3.19, 6.2, 6.3: © Bettmann/CORBIS

3.22: © Genevieve Naylor/CORBIS

2.20, 6.1, 6.12, 7.5, 7.12, 9.5, 9.7: CORBIS

8.10a: Eric/Vogue © The Condé Nast Publications Ltd

9.3, 9.4, 9.6: Firstview.com

2.8: Horst © Vogue Paris

5.8: Keogh © Vogue Paris

8.8: Balenciaga Mantle Coat (A), Paris, 1950 (renewed 1978) © Condé Nast Publications Inc. Irving Penn © Vogue Paris

8.12: Salad ingredients, New York, 1947, Copyright © 1947 (renewed 1975) Condé Nast Publications Inc.

1.11: Vernier/Vogue © The Condé Nast Publications Ltd

p.8, 1.13, 2.10, 2.19, 2.24, 3.1, 3.3, 3.4, 3.10, 3.12, 3.15, 3.19, 5.2, 6.8: Time Life Pictures/Getty Images

8.14, 8.16: © René Gruau SARL

2.6: Laurent Sully Jaulmes, courtesy of Maryhill Museum of Art

Jacket/cover spine, 2.29: Willy Maywald. © Association Willy Maywald/ADAGP, Paris and DACS, London 2007

1.7, 4.13: National Portrait Gallery, London. © Norman Parkinson Archive

p.2: Norman Parkinson Archive

3.11: POPPERFOTO/Alamy

1.14: Queen Magazine

1.1, 2.2, 6.4: Sotheby's Picture Library, London